MOUNTAIN PASSAGES

Natural and Cultural History of Western North Carolina and the Great Smoky Mountains

GEORGE ELLISON

CHARLESTON LONDON
History
PRESS

Published by The History Press
18 Percy Street
Charleston, SC 29403
866.223.5778
www.historypress.net

Cover Painting: *A Mountain Morning* by Elizabeth Ellison

First published 2005
Second printing 2005
Third printing 2006

Manufactured in the United Kingdom

ISBN 1-59629-044-7

Library of Congress Cataloging-in-Publication Data

Ellison, George, 1941-
 Mountain passages : natural and cultural history of western North Carolina
and the Great Smoky Mountains / George Ellison.
 p. cm.
 Includes bibliographical references.
 ISBN 1-59629-044-7 (alk. paper)
1. Natural history--North Carolina--Anecdotes. 2. Natural history--Great
Smoky Mountains (N.C. and Tenn.)--Anecdotes. 3. North Carolina--History,
Local--Anecdotes. 4. Great Smoky Mountains (N.C. and Tenn.)--History,
Local--Anecdotes. I. Title.
 F261.E45 2005
 975.6'96--dc22
 2005008815

For Elizabeth,

Who makes the stars twinkle and the earth spin around

Contents

Preface 7

Map 9

Natural History

Magical Waters 13

Mountain Waterfalls and the Saga of Chunky Joe Huger 15

The Lay of the Land 19

The Season of Colors 23

Mountain Critters: Eastern Bison and Wild Boar 25

First Observations: Bishop Augustus Gottlieb Spangenberg 31

John Fraser and the Economics of Plant Exploration 35

Mountain Ornithologist: John S. Cairns 37

Park Naturalist: Arthur Stupka 41

Cherokees

Ancient Fishing Strategies 47

Sochan and Other Wild Greens 49

Booger Masks: Cherokee Mirrors 53

Masters of the Night: Cherokee Owl and Witch Lore 57

Nantahala Indian Caves 61

Cowee Bald and the Powder Horn Map 65

Big Bear's Reserve: From Indian Village to Mountain Town 69

Tsali, Tsali's Rock and the Origins of the Eastern Band 71

Swimmer, Mooney and the Sacred Formulas 77

Geronimo and the Eastern Band 81

Mountaineers

A Peculiar Duel: Vance versus Carson (1827) 87

Cages, Dungeons and Jailhouses 91

Boardinghouse Memories 95

Springs, Springboxes and Springhouses 99

Goldenseal as a Medicinal 101

Weather Sharps 105

The Hermit of Bald Mountain: David Grier 109

The Calloway Sisters 111

An Original Character: Quill Rose 115

Bryson City Island: Ironfoot Clarke's Abode 119

What's in a Name? Turkey George Palmer 121

Fly Fisherman Extraordinaire: Mark Cathey 125

High Vistas: Pearly Kirkland, Fire Tower Dispatcher 129

Thomas Wolfe's Angel: Hendersonville or Bryson City? 133

Horace Kephart: Outdoorsman, Writer and Park Advocate 137

Stark Love: Karl Brown's 1927 Mountain Movie 145

Kephart Prong: Past and Present 149

Sources 153

About the Author and Illustrator 157

Preface

A quick glance at the table of contents for this gathering suggests the range of interests I've entertained since my wife and I chose to make our home in the mountains of Western North Carolina more than thirty years ago. I would have, no doubt, developed similar interests and strategies had we chosen to live in, say, southeastern Arizona in the Chiricahua Mountains.

As a number of the selections indicate, I'm continually intrigued by the manner in which the natural and human histories of any given region overlap and eventually—in certain places more than others—commingle. That process is ongoing, of course, anywhere one chooses to reside, but in no place I've experienced or read about is there a richer context than here in these mountains. As a writer about general topics and a field naturalist, I've been given ample opportunity to observe and try to record these processes in my own way. For this I'm thankful.

Along the way, I have also been captivated by individual personalities from out of the past who either were native to the region or had been attracted here, for whatever reasons, from the outside world. In this gathering, it's a cast of characters that includes early explorers and plant hunters, ornithologists, a naturalist, a Cherokee shaman or two, weather sharps, a hermit, a fire tower dispatcher, several writers of note, stone angels and a plethora of "original characters," as defined in one of the pieces.

In other instances, it's been specific events that have focused my attention. For this selection, I've chosen to present ones pertaining to the killing of the last buffalo and the introduction of the wild boar into Western North Carolina, the Cherokees

during the eighteenth and nineteenth centuries, an 1827 duel that wasn't really a duel and the filming of a movie titled *Stark Love* in 1927.

These materials have been gathered into three broad categories: natural history, Cherokee history and lifestyles, and mountaineer history and lifestyles. Within each of these, I've arranged the selections chronologically or, when that wasn't applicable, thematically. The original columns usually contained the full title and date of publication for printed sources. So that those interested in doing so can more readily locate these materials for their own uses, I've provided fuller citations—as well as additional information, like Internet addresses—in the Sources section.

These selections originated, in their present form, in a weekly column titled "Back Then" that I've contributed to *Smoky Mountain News* since October 2000. *Smoky Mountain News* is a regional newsmagazine with a distribution of sixteen thousand copies per issue, which is published in Waynesville and distributed in the North Carolina counties west of Asheville. I've been somewhat amazed to find that the publication also achieves a much wider readership via the Internet. Accordingly, I receive weekly e-mail feedback from readers not only in the immediate region and across the United States but also from places as far-flung as Australia, Mexico, Scandinavia, England, Ireland, France, Germany and Spain. There seems to be a wide interest in the southern mountains in general and Western North Carolina in particular, especially in regard to Cherokee history and culture.

Smoky Mountain News editor Scott McLeod has pretty much given me free rein in regard to the subject matter and the length of my "Back Then" columns. They have mostly hovered in the vicinity of eight hundred words per contribution, but whenever I've required twelve hundred to two thousand words to cover the subject, he hasn't, as yet, flinched. I very much appreciate the level of professionalism Scott and his entire staff display on a day-to-day basis.

I was pleased when The History Press editor Amanda Lidderdale contacted me about publishing a gathering of these columns. She, editorial co-ordinator Julie Hiester and managing editor Kirsten Sutton have been most helpful. I'm especially indebted to Amanda for wading through two hundred or so columns and helping me make a representative selection.

And finally, of course, there's my wife, the artist Elizabeth Ellison, who not only contributed the cover painting and the decorative drawings that serve to divide each section but proofread each of them more than several times. Her corrections and suggestions were invaluable.

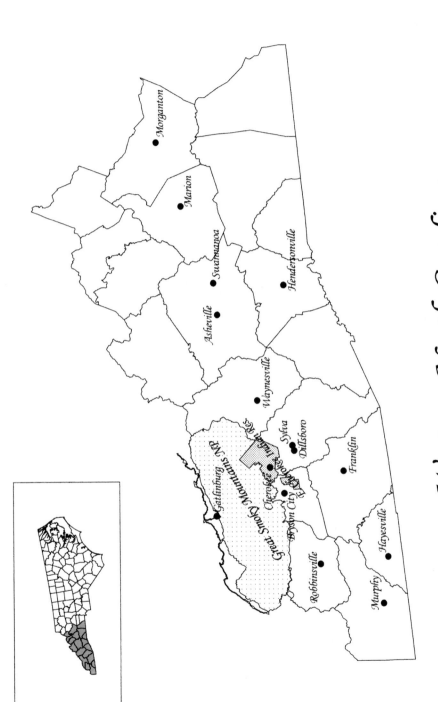

Western North Carolina *Courtesy of Anita K. Oser*

NATURAL HISTORY

Magical Waters

Almost every evening before supper, my wife, Elizabeth, and I stroll down the pathway below our home. This path leads for almost a mile to a little waterfall. We always pause to sit a while on a bench that overlooks the cascade and the swirling pool below. Returning home, we vary the route some by crossing several footbridges that lead into and out of a pasture situated across the creek from the house. These outings take only about half an hour, but we always come back renewed, especially during the winter months. The creek never fails to lift our spirits.

Creeks are as central to life here in Western North Carolina as the mountains themselves. You can't have mountains like the ones found here without the seeps, springs, branches, creeks and rivers that form them. Flowing water was the primary agent that sculpted the mountain landscapes as we know them today. The word *creek*, in addition to being defined as "a small stream, often a shallow or intermittent tributary to a river," means "any turn or winding." The word may derive from the Old Norse *kriki*, meaning "a bend, nook."

Bends and nooks are the essence of any creek. They are magical places where the water swirls and threads its way over and among a jumble of boulders, disappears under a cutbank, braids its way through a sluice, purls in an eddy and glints in the winter sunlight.

Ask anyone here in Western North Carolina who doesn't reside in a town or settlement where he lives and he'll more often than not designate either a mountain

or a creek. Many will say something like, "Up at the head of Kirkland Creek," or "Down on Snowbird," or "Out at Alarkie," which means that they reside on Alarka Creek.

Native mountaineers always know every foot of the creek they were raised up on, having fished, hunted and walked it in all seasons since childhood. They can and do walk their home creeks almost as easily in pitch dark as in daylight.

Each creek is a distinctive natural area with its own set of plants and animals. Spicebush and shrub yellowroot hug a creek's banks, dependent upon the flowing water to distribute seeds especially adapted for flotation. Belted kingfishers and Louisiana waterthrushes establish narrow territories along clearly defined stretches. Water shrews have evolved fringes of hair on their feet that enable them to dive underwater to seek food or run on the surface to escape predators.

Mountain pathways almost inevitably wind down to and alongside creeks. They are irresistible. Each bend and nook has its own voice: the unique set of sounds that arises from the confluence of water running at a given rate over a particular configuration of logs and stones. We are attracted when moody or meditative to certain creeks where these sounds become voices that speak to us quite clearly.

Mountain Waterfalls and the Saga of Chunky Joe Huger

Here in the mountains, water is the essence of our very being. Long before the first Europeans arrived, the ancient Cherokees had developed ceremonials focused on the spiritual power of running water. One of the prized sites for such purification ceremonies was a waterfall. It was there that the Cherokees could hear a river—which they identified as "the Long Man"—speaking to them in the clear voice of the raging current.

Along with scenic vistas, waterfalls are still one of the most sought-after natural attractions here in the southern mountains. They are dynamic places that seem to encourage contemplation. Their spray zones and grottoes are home to unique plants and wildlife. Ferns and salamanders that can be found no place else in Appalachia—or even the entire world—have their homes in the ecological niches provided by our high country cascades.

Whenever I'm conducting a natural history workshop that encounters a waterfall, I ask participants to contemplate a bit as to why waterfalls are so appealing. Invariably, such qualities as constant motion, soothing sound, spiritual tranquility, natural beauty and harmony of sight and sound are mentioned.

The Great Smoky Mountains Natural History Association recently published a brochure titled *Waterfalls—Great Smoky Mountains National Park* (1998), edited by Steve Kemp. In a section headed "The Joy of Waterfalls," I was delighted to be informed that researchers have concluded that waterfalls "generate negative ions which make people feel good. Negative ions are negatively charged air molecules

created by a number of natural and electronic processes, including ocean surf and waterfalls. Negative ion levels at large waterfalls are estimated to be 50 times higher than at other rural sites. Brighter moods, increased energy, improved physical performance, and better health are just some of the benefits that have been ascribed to exposure to high concentrations of negative ions."

The same source notes that waterfalls also create "soothing white noise," the sort of constant sound engineers try to duplicate in order "to help humans relax, concentrate, or sleep," and, furthermore, that the "cooling mist" found at waterfall sites creates "a 100% natural, energy efficient form of evaporative air conditioning." Negative ions, white noise and evaporative air-conditioning—your waterfall visits may never be the same again!

In his *Out Under the Sky of the Great Smokies: A Personal Journal*, explorer and author Harvey Broome observed, "We see eternity in waterfalls—perfect motion working independently of humankind, fueled by nothing more than gravity and rain." Well, maybe so in regard to the "perfect motion" part, but waterfalls are not eternal. They have life spans just like us human critters.

The life cycles of waterfalls display two basic patterns. One is the slow cutting down of an extended stratum of rock of more or less the same density. In this instance, a series of smaller cascades appears. Subsequent erosion then hones down the cascades into a stretch of turbulent whitewater that will in time blend in with the smooth flow of the rest of the stream. In the other instance, the top layer of rock forms an erosion-resistant "cap" so that most of the erosion takes place at the base of the falls, carving out a deep plunge pool in the streambed. Churning debris in the plunge pool then wears away the weaker rocks in the lower part of the cliff so that the undermined portion of the cap breaks off, leaving a new one slightly upstream. In this manner, the waterfall slowly migrates upstream, often leaving a series of plunge pools in the riverbed that mark the former locations of the waterfall.

Early in the twentieth century, Chunky Joe Huger, waterfall aficionado par excellence, was inordinately attracted to the varied cascades he could locate in the southern mountains. Huger's curious life and adventures were delineated by Jim Bob Tinsley in *The Land of Waterfalls: Transylvania County, North Carolina* (1988), which is illustrated with black-and-white photos the author took of sixty or so waterfalls over a forty-year period. It's a state-of-the-art waterfall book, detailing locations, Cherokee lore and historical information for each of the sites.

"In the remote southwest corner of Transylvania County [he] called 'the paradise of Cascadia,' Arthur Middleton Huger, a picturesque South Carolinian of French descent, sketched and described plant life, revived Cherokee names from ancient charts, and gave 'fitting' names to waterfalls when they had none," Tinsley recorded. "Mountain people had difficulty with the Huguenot way of pronouncing Huger; in one of his many letters, the botanist tried to explain: 'When you enquire for me pronounce name (U.G.) you-gee, soft g.'

"Huger once wrote about the articles he carried during his continuous treks in the mountains: 'I am obliged to "tote" underwear, sketchbook, a flask of Frisky, and other impedimenta.' No wonder footing was unsure for him at times. Slippery Witch Falls is on Mill Creek below the Sapphire Road. 'Chunky Joe' had trouble with his footing along the stream and told people the spillover was a 'slippery bitch.'"

According to Tinsley, Huger described Whitewater Falls along the state line between North Carolina and South Carolina in this manner:

> *In my tramps I have seen many a "spatter-dash," but in boldness and picturesque beauty never one to equal the "White Thunders of Thornateska." Cascades and cataracts, as a rule, are in deep gorges usually shut in by densely forested ridges, but here one finds the first of "Three Thunders" beside the dash of the dazzling foam and the upward leap of a jet that shoots 12 or 15 feet—I call it the "Plume of Navarre"—before its storm of tumbling stars plunges into the depths. There is a wide panorama to the southeast, near-by the "Vale of Jocassee," far below, hedged in by the forested billows of the Blue Ridge, and beyond for a hundred miles or more the "Under Hills" of South Carolina, the remote region as level as that of the sea—and far more beautiful.*

Now that's purple prose of some intensity, but Huger had seen a lot of waterfalls in his day and knew a good one when he spotted it. And he was absolutely correct in noting that the Whitewater Falls area provides an unusual situation in regard to overlooking both a stupendous gorge-waterfall site as well as vast portions of the surrounding lowlands.

The Lay of the Land

Oone can "get the lay of the land" in several ways. If your hiking partner says that he or she is "going on ahead to get the lay of the land," that's one thing; on the other hand, if he or she is your business partner and flies to Dallas to get the lay of the land in a business deal, that's something else.

Here in the southern mountains the phrase is best applied, of course, to topography. For my money, there's no other place in the world that surpasses the varied landscapes of the southern mountains in general and of Western North Carolina in particular. And there's no place I know of where the people of the region use a more delightful language in describing their homeland.

In his *Smoky Mountain Folks and Their Lore* (1960), the folklorist Joseph S. Hall enumerated some of the stories and phrases he collected in the Smokies region during the late 1930s. Much of the language he encountered had to do with "getting the lay of the land."

Hall learned that a *bald* was "a treeless mountain top characteristic of the Smokies, as in Bearwallow Bald." Botanists recognize a second kind of bald they call a *heath bald*, which is a treeless tangle of rhododendron and other shrubs in the heath family. Hall found that they were known locally by such names as "laurel bed, lettuce bed, rough, slick, wooly (as in wooly head, wooly ridge, wooly top), and laurel hell."

A *bench* is "a level area, sometimes cultivated, on the side of a mountain" while a *butt* is "the abrupt end of a mountain ridge, as in Mollies Butt, at the end of

Mollies Ridge." A *knob* is "a mountain top" while a *lead* is "a long ridge, usually extending from a higher ridge, as in Twenty Mile Lead." I would augment Hall in this regard by adding that a *spur* is "a lateral branch leading from a ridge or 'high top' that usually terminates abruptly"; furthermore, a *sag*, or *swag*, is a low-lying area along a ridge that's not quite low enough to qualify as a *gap*.

Back to Hall's account, where he noted that a *cove* is "a widening out of a mountain valley, or a meadow land between mountains, as in Cades Cove, Emerts Cove." Coves are closely related to *hollows* (properly pronounced "hollers"), which are small valleys, "as in Pretty Hollow." I would add that a *bottom* is flat land, usually along a stream.

Hall recorded that a *deadening* is "an area where the trees have been killed by girdling" (in order to clear the land for farming). Thereby, bottoms would often be deadened so as to create a deadening. Conversely, a *scald* is "a bare hillside" created deliberately or unintentionally by fire, which becomes a *yellow patch* when it has "grown up with thick brush."

I am personally intrigued by the terms associated with water. First, there are *seeps* and *springs*, or *springheads*. If a spring is referred to as being "fittified," this means that it is intermittent or "spasmodic" and therefore unreliable. Reliable springs become *brooks* and then *creeks* and finally *streams* or *rivers*. *Shoals* are shallow, rocky places along waterways that can be treacherous. When a *branch* passes through a "a marshy place" or *ravine*, it becomes a *run*.

In a handbook compiled by Allen R. Coggins titled *Place Names of the Smokies* (1999), we discover that the topographic aspects of the mountain landscape have been immortalized in a manner that is always descriptive, often humorous and sometimes poetic.

Advalorem Branch in Swain County refers to "a tax based on a percentage of assessed value," and Arbutus Branch in Cades Cove has the vine named trailing arbutus growing in abundance along its banks.

Ballhoot Scar Overlook at Smokemont is a place where logs were rolled ("ballhooted") down the slope, creating bare areas (*scars*), and you already know why an area near Gatlinburg is named Bill Deadening Branch.

The place known as Blowdown at Thunderhead Mountain along the state line in the high Smokies is "named for an area where a wide swath of trees were blown down by a storm in 1875."

Crooked Arm is a mountain spur in Cades Cove shaped like an elbow that is drained by Crooked Arm Branch, which features Crooked Arm Falls.

One of the places I'd like to visit is on Mount Le Conte. You already know what a "fittified" spring is. The one to which that name is assigned on Mount Le Conte is reputed to have been created by an earthquake in 1916. It ran like clockwork with a "seven minute on, seven minute off flow pattern" until 1936, when a dynamite blast set off by a Civilian Conservation Corps trail construction crew disrupted that pattern. Little wonder, then, that thereafter it became "fittified."

I've been to Miry Ridge at Silers Bald along the state line. As Coggins notes, it's "knee-deep in places" with "black muck." And I've been to Mule Gap in the same area, where Tom Siler operated a mule lot.

I'd enjoy visiting the Dry Sluice on Mount Guyot. Coggins describes this site as being "named for a small hollow or valley called a sluice, which has a spring-fed stream that sinks beneath the surface for several hundred yards before resurfacing. Hence the upper part of the sluice is generally dry." But the origins of place-names can be tricky. Coggins adds, in regard to Dry Sluice, that "This name may also be linked to the early logging industry, when logs were sluiced (moved down the mountain) from timber cutting operations."

One could ramble on in this regard. Maybe some fine day—while getting the lay of the land—I'll run into you up at Deeplow Gap or atop Holy Butt or somewhere along the Boogerman Trail.

The Season of Colors

Somber habiliments appear to be the lot of mankind in his old age, yet the mellowing year marks its periods of decline with a pageantry of hues so varied that it is, as Walt Whitman said, "enough to make the colorist go delirious." Here in the forests of the Blue Ridge, where well over a hundred kinds of native deciduous trees are to be found, the spectacle challenges description; the writer feels humbled and gropes for words.

Arthur Stupka, *The Great Smokies and the Blue Ridge* (1943)

For those of us who live to get out and tramp around in the woods or drive to some high vista, fall is the finest season. Emerging from their late-summer doldrums, our senses are sharpened by the clear blue skies of autumn. The repetitive notes of an axe biting into wood ring crisply through the woodlands. Wood smoke spirals upward from a home secluded in a remote cove. In a glistening frost, the world about us is redefined. But first and foremost, fall is the season of colors.

The forests of the southern mountains contain an astonishing array of deciduous trees that put on a show each fall that entices leaf lookers to flock into the region from all over the world. The story behind this color pageant is as interesting as it is colorful.

Spring and summer leaves are green because of chlorophyll, the pigment that enables leaves to manufacture food via photosynthesis. Leaves also contain other pigments at this time, but the dominant green of the more abundant chlorophyll masks them.

Determining all of the factors involved in the creation of fall leaf colors and predicting a given season's intensity can be tricky, if not downright impossible.

But there are two basic factors one can consider from year to year. The first is a constant. With late summer and fall's shorter days, leaves stop producing as much chlorophyll. Other colors, especially yellow, emerge as pure pigments. Carotene and other yellow pigments cause the leaves of pawpaw, spicebush, witch hazel, mulberry, hickory, black locust and other species to glow softly in the woodlands like candles.

The second factor varies from year to year in terms of when it kicks in. A cool snap of about thirty-five to thirty-seven degrees Fahrenheit in late September or early October (usually before October 10, our average true frost date in Western North Carolina) activates the formation of a corky layer at the point where leaf stems connect to their twigs. This connection point is clearly defined by a swollen nodule that botanists call the abscission layer. As this nodule hardens, the flow of water and minerals to the leaf is cut off so that it can no longer produce chlorophyll. At this time, the previously masked colors really start to appear. Compounds called anthocyanins brighten the landscape with reds and oranges. Those leaves that contain significant amounts of sugar—such as sugar maple and black gum—undergo a chemical reaction that results in the brightest red colors. If the leaves contain significant amounts of tannin—as is the instance with the various oak species—brown and maroon colors are dominant.

In most tree species, a given leaf separates from its twig at the abscission layer and sails to the ground by late fall or early winter. For reasons that I've never been able to determine, some species of oak and, especially, American beech, "hold onto" their leaves through the winter months.

The theory of foliar fruit flagging advanced in recent years by various biologists should be an item of interest for any serious leaf looker. According to this theory, species like poison ivy, Virginia creeper, black gum, sassafras, spicebush, dogwood, the sumacs and the wild grapes produce an early flush of foliage color in late August through mid-September, while most of the forest is still green, so as to attract migrating birds to their already-ripened fruit and thereby ensure an adequate distribution of seed.

Each year in mid-fall, we can gaze out in silent awe over this mountain homeland—from some high vista like Waterrock Knob, Clingmans Dome, Mount Pisgah, Wayah Bald, Frye Mountain or Balsam Mountain—at the final result of these intricate processes.

Mountain Critters:
Eastern Bison and Wild Boar

Buffalo Knob...Buffalo Branch...Buffalo Cove...all are common place names in Western North Carolina that indicate the prior residence of those formidable mammals in these mountains. Whenever I conduct workshops on the region's natural history, queries about the buffalo always arise. The only other four-legged critter that rivals it in general interest would be the European boar, which was introduced during the early part of the twentieth century. Here, then, are some observations concerning the eastern bison and the wild boar.

I used to suppose that the species of bison that roamed the southern mountains was the wood bison, one of the two bison subspecies generally recognized in North America. After looking into the matter more closely, however, I now have a different opinion. First, let's take a look at the historical record.

The buffalo was certainly here many centuries before the Cherokees emerged as a distinctive culture about a thousand years ago. They knew the great beast as *yansa* and utilized it for clothing and food. According to Arlene Fradkin, in her *Cherokee Folk Zoology: The Animal World of a Native American People, 1700–1838* (1990), the horns were made into surgical instruments for curing swellings from boils and toothaches as well as for war trumpets. Buffalo hooves were sometimes worn on warriors' feet during war expeditions so as to deceive the enemy. To this day the buffalo dance is still a favorite among the remnant Eastern Band of Cherokees here in Western North Carolina.

John Preston Arthur, in his *Western North Carolina: A History (from 1730 to 1913)* (1914), noted that when Hernando de Soto's men explored this area in 1540,

they were presented with a dressed buffalo skin by the Cherokees. This, Arthur speculated, was perhaps the first such skin "ever obtained by white men." The Spaniards described it as "an ox hide as thin as a calf's skin, and the hair like a soft wool between the coarse and fine wool of sheep."

The first recorded British observation of buffalo in eastern North America was documented by William T. Hornaday in *The Extermination of the American Bison* (1889). It took place "somewhere near Washington, District of Columbia, in 1612, by an English navigator named Samuell Argoll, and narrated in a letter published as follows in *Purchas: His Pilgrimes* (1625): 'And then marching into the Countrie, I found great store of Cattle as big as Kine, of which the Indians that were my guides killed a couple, which we found to be very good and wholesome meate, and are very easie to be killed, in regard they are heavy, slow, and not so wild as other beasts of the wildernesse.'"

The most extensive contemporary account of the buffalo in Western North Carolina that I've been able to locate comes from the famous diary kept by Bishop Augustus Gottlieb Spangenberg (1922). Therein, Spangenberg portrayed in detail his exploration of the western portion of the colony in 1752–53 on behalf of the Moravian Church. He noted that the land was "frequented by buffalo, whose tracks are everywhere, and can often be followed with profit. Frequently, however, a man cannot travel them, for they go through thick and thin, through morass and deep water, and up and down banks so steep that a man could fall down but neither ride nor walk!"

William G. Lord, in his *Blue Ridge Parkway Guide: Grandfather Mountain to Great Smoky Mountains National Park* (1990), provided a description of the method used by pioneer hunters when pursuing bison: "At first they were so plentiful that a small hunting party with dogs could kill ten to twenty a day. The animals depended on their noses rather than their weak eyes to warn them of danger, and men could approach within easy gun range provided they kept downwind."

If you stop at the Bull Creek Valley overlook, at milepost 373, along the Blue Ridge Parkway north of Asheville, you'll be looking down into the Swannanoa Valley. Nearby is Bull Gap, and down in the valley is Bull Creek. All three of these place-names commemorate the grizzled old bull bison—the last of his kind in the Blue Ridge—shot by Joseph Rice along that creek in 1799.

Rice was one of the first settlers in the Swannanoa Valley. His killing of the last bison has been described in various ways in various sources. Here's the account provided by Frank L. FitzSimons in volume 2 of *From the Banks of the Oklawaha* (1977):

> *Pausing in his back-breaking work to mop the sweat from his brow, Rice caught the sound of the fierce rumbling and bellowing of the lonely old bull plodding slowly along the ancient animal trail. The man recognized the sound as the wind brought it down to where he was working. He knew what it was from earlier experience in his pioneer wanderings [so] he waded the creek and started up the trail. He knew that he need not be too cautious. He was downwind from the bull. Rounding a bend in the path, he caught sight of the raging animal*

pawing dust high in the air. The man crept quietly now until he was within shooting range. He took careful aim and squeezed the trigger. The powder charge in the long muzzle-loading gun boomed like a clap of thunder. The lead bullet thudded into the old bull. There was a blinding, startling flash in the brain of the brute. The booming mating call ended in a death scream and the huge animal crashed to the ground.

On that sad note, let's return to the original question: Exactly what sort of buffalo resided here in Western North Carolina? First, we need to look at the taxonomic record. The *Encyclopaedia Britannica* indicates that a bison is "either of two species of ox-like grazing mammals that constitute the genus *Bison* of the family *Bovidae*. The American bison (*Bison bison*), commonly known as the buffalo, or plains buffalo, is native to North America, while the European bison (*Bison bonasus*), or wisent, is native to Europe…Some authorities distinguish two subspecies of American bison, the plains bison (*Bison bison bison*) and the woodland [wood] bison (*Bison bison athabascae*)."

Various sources describe the wood bison as having been a resident of boreal forests in western Canada. Today, there are small remnant herds of them in that region. This seemingly leaves us with some sort of plains bison. The authors of *Mammals of the Carolinas, Virginia and Maryland* (Webster et al. 1985) observed that "Very little is known about the biology of the eastern bison, but it was presumably similar to the plains-dwelling bison of the west." And Roger A. Caras, in his *North American Mammals: Fur-Bearing Animals of the United States and Canada* (1967), mentioned in passing two subtypes of the plains bison: a "pale mountain bison of Colorado" and an "eastern bison of Maryland, Pennsylvania, and Virginia."

The bison found here in the southern mountains were usually described as being smaller, more compact and better adapted to navigating woodlands and mountainous terrains than the western form. I'm now of the opinion that our bison here in Western North Carolina was Caras's "eastern bison" and that it was an ecological (not a genetic) variant of the plains bison.

In regard to their residence in Western North Carolina, the eastern bison and the European wild boar are polar opposites. Once a native of the region, the eastern bison was fully extirpated as of more than two centuries ago. Introduced less than a century ago from another continent, the wild boar is currently thriving and more than holding its own throughout the Great Smoky Mountains National Park, extensive portions of Western North Carolina and East Tennessee and, to a lesser degree, adjacent portions of the southern mountains.

Numerous nonnative plants have been introduced into the region during the last century or so. Some are now classified as "exotic pests" by wildlife biologists. Few would argue that kudzu does not fall into this category. On the other hand, the European wild boar was surely the most notable alien mammal ever introduced into the immediate region. Labeling the wild boar as an exotic pest may be understating the case.

There are supporters of the wild boar—mostly hunters—who contend that the animal's outstanding qualities as a game animal outweigh its negative qualities. Then there are those who have observed its capacity to devastate large areas that think otherwise. I used to be a friend of the wild boar. Its survival instincts and ability to adapt to truly rugged mountain terrain seemed to be admirable traits in any animal. In recent years, however, after some up close and personal encounters, I've changed my mind. We'll get to those issues later.

In a twenty-nine-page pamphlet titled *The European Wild Boar in North Carolina* (1959), Perry Jones delineated the story of how the animal arrived and subsequently flourished in Western North Carolina. In 1908, the Whiting Manufacturing Company, an English concern, purchased Hooper Bald and adjoining lands near Robbinsville in Graham County. George Gordon Moore, an adviser to English investors, was allowed to establish a sixteen-hundred-acre game preserve on Hooper Bald in return for assisting the company with floating a loan of two million dollars.

Beginning in 1912, Moore's preserve was stocked with 8 buffalo, 14 elk, 6 Colorado mule deer, 34 bears (9 of which were Russian brown bears), 200 wild turkeys, 10,000 English ring-neck pheasant eggs and 13 wild boars. For good measure, he also purchased 150 sheep and 150 turkeys locally.

"Almost immediately," Jones noted, "blows of adversity began to strike the preserve. Some of the big bears promptly climbed out of the wire stockade, and since several of them had come from zoos, they would proceed to the clubhouse for food. The thought of a large bear appearing at any moment made sleeping extremely difficult. In order to return a bear to the lot, two men would have to lasso each of his front feet, pull him around a tree, and securely bind both pairs of feet together on the opposite side of the tree. Next a pole was placed across the back of his neck, and his chin was pushed up firmly against the tree. While two men would hold this pole, another would put a collar securely around the bear's neck. Two chains were then snapped on the collar. The pole and ropes were then removed, the bear was 'collared,' and the two men at the extreme end of the chain would hold the bear off each other. This procedure was described as 'spread-eagling' a bear."

So, there you go—the next time you need to deal with a bear, you'll know exactly what to do: just "spread-eagle" the varmint.

According to Jones, the bears "fell prey to sharp-shooting mountaineers," and all of the other animals rather quickly faded away in an environment they couldn't cope with—all, that is, but the wild boars.

Area residents have long referred to the wild boar as the Russian (or "Roossian") wild boar, but Jones speculated that the animals actually came from Germany. At any rate, they were the only critters to escape from the preserve and survive for any length of time in the surrounding mountains.

"One source states that the wild boar were capable of sticking their legs between the rails of their pen and actually climbing over the fence," Jones noted. "It seems

likely, however, that the majority of them chose to remain within the enclosure where they were allowed to reproduce unmolested for a period of eight to ten years."

In the early 1920s, Moore's foreman, Cotton McGuire, a Graham County resident who provided most of the information Jones collected, "invited some of his friends who owned packs of dogs up to the Bald for a grand hog hunt. This hunt was conducted within the boar lot, and by this time the boar had increased to an estimated herd of between 60 and 100. The boar, however, turned out to be more than the hunters or dogs bargained for. Only two were killed, and at least a dozen dogs were killed, or severely maimed. Some of the hunters were forced to take refuge in trees to escape the charging beasts. Overly excited by the baying of dogs and shouts of hunters, the boar simply tore their way through the fence and escaped into the nearby mountains."

Established in 1934, the 520,000-acre Great Smoky Mountains National Park has become their prime sanctuary, despite extended shooting and trapping campaigns by the park service to eradicate them because of their destructive habits. A mature animal can attain a height of more than three feet at the shoulder and a weight of more than four hundred pounds. The average weight, however, is probably less than half that.

Ranging widely in herds, they are omnivorous, feeding on plant matter and small animals. The head of the wild boar is wedge shaped with a pointed snout, which enables it to root up the ground to locate underground tubers for food. According to Jones, "Their menu also includes acorns, grains, fruits, birds' eggs, mice, carrion, and salamanders. During the spring and early summer, chick grouse and green corn…are also included in the diet. The imported boars seem particularly to relish rattlesnakes, which they kill with their sharp-edged hooves…Alone or in herds a boar may travel up to 12 miles during one feeding period."

Troy Hyde, a veteran Graham County hunter, told Jones that a boar could "root up concrete, if he put his mind to it." That's an exaggeration, of course, but not too much of one. The first time I encountered an area that had been visited by boars, I momentarily wondered what fool had been rototilling in the national park. Then the hog smell betrayed the culprits' identities. I was astonished at the extent of the damage.

But just how destructive they can be didn't really hit home until about ten years ago, when they started making nighttime forays onto our property, which adjoins the national park on three sides, and commenced digging up some of the richest wildflower areas we had. (They especially relish the tubers of the showy spring species: bloodroot, trillium, rue anemone, blue cohosh, trout lily, etc.) When we returned home after an extended absence, my first thought once again was that some fool had rototilled the slope behind the house. Then I smelled that smell and saw the hog tracks.

At that time we had to temporarily discontinue using our gravity-flow water system because the critters decided to root and wallow in the watershed up on the side of the ridge above our home where the springhead is situated. North Carolina

Wildlife Resource Commission officers issued us an out-of-season hunting permit to help remedy the problem. But I didn't have enough firepower to make a stand. The pellets from my 12-gauge shotgun would have only tickled a boar's funny bone. (Wild boars do have funny bones, don't they?) Anyway, I never fired a shot. After a while, they upped and left on their own. Good riddance, we thought.

But, alas, they returned again the following year, while Elizabeth and I were away for a week. This time they attacked a partly buried rock wall above the house. The sixty-foot-long dry wall had been built more than a century ago by a farmer clearing the hillside to plant corn. We suppose there was something living in or under the wall that the wild boars craved. The hillside looked like several grenades had been detonated under the wall, throwing rock debris in a helter-skelter array. And the boars continue to this day to pay us periodic unannounced visits.

Wild boars are independent cusses that made the transition from one continent to another with admirable ease. They didn't asked to be hauled from Europe to Western North Carolina, but they've made a go of it without any whining or bellyaching. In my opinion, that's admirable. But you can't really be the friend and supporter of an animal that pollutes your water supply, digs up your wildflowers and uproots rock walls on your property, can you? Even kudzu doesn't do that.

First Observations:
Bishop Augustus Gottlieb Spangenberg

In 1728, Colonel William Byrd of Virginia and his party had just completed a survey of the boundary line between Virginia and North Carolina from the Atlantic Ocean to Peters Creek in present-day Stokes County. From a high hill, they could look westward and see the Blue Ridge front looming about thirty miles in the distance. Subsequently, Byrd lamented in his *History of the Dividing Line Run in the Year 1728* (1929) that "Our present circumstances wou'd not permit us to advance the Line to that Place, which the Hand of Nature had made so very remarkable."

Had Byrd and his party pushed on through the foothills of the piedmont provinces of Virginia and North Carolina, they would have quickly penetrated the real mountains. In that instance, Byrd's descriptions of the area would no doubt be ranked today as the high-water mark in the descriptive and natural history literature of Western North Carolina prior to the arrival of William Bartram in 1775. That honor, instead, must go to Bishop Augustus Gottlieb Spangenberg, who kept a fabulous diary in which he portrayed in vivid detail his exploration of Western North Carolina in 1752–53 on behalf of the Moravian Church.

Spangenberg (1704–92) was born in Prussia and in time became a professor of religion. He had previously been acquainted with Count Nicolaus Ludwig von Zinzendorf and the Moravians and was much impressed with their missionary zeal; indeed, his association with them gave such offense that he was dismissed from his university position. Accordingly, he promptly joined the Moravian Church and became Zinzendorf's assistant.

Spangenberg placed himself during the 1730s at the head of a body of Moravian immigrants and established a colony at Savannah, Georgia. In 1744, he became overseer of the Moravian settlement at Bethlehem, Pennsylvania, where, with the exception of a brief period from 1749 till 1751, which he spent in Europe, he governed the church until 1761 with singular ability.

In 1752, Bishop Spangenberg made his way to Edenton, North Carolina. His assignment was to oversee the survey of a hundred-thousand-acre tract of land in the North Carolina interior that John Carteret (Lord Granville) had offered to Zinzendorf. Starting on September 10, 1752, the Moravian party traveled westward from the coast, headed for adventures they could never have imagined in their wildest dreams.

By November 24, they had reached the foothills of the Blue Ridge in present-day Burke County, east of present-day Asheville. As Spangenberg noted in his diary, this was a land far beyond the meager comforts of the Colonial frontier; his party had penetrated the true wilderness that then existed in the western piedmont region:

> *The land is very rich, and has been much frequented by buffalo, whose tracks are everywhere, and can often be followed with profit. Frequently, however, a man cannot travel them, for they go through thick and thin, through morass and deep water, and up and down banks so steep that a man could fall down but neither ride nor walk!...The wolves here give us music every morning, from six corners at once, such music as I have never heard. They are not like the wolves of Germany, Poland, and Livonia, but are afraid of men, and do not usually approach near them. A couple of Brethren skilled in hunting would be of benefit not only here but at our other tracts, partly to kill the wolves and panthers, partly to supply the Brethren with game. Not only can the skins of wolves and panthers be sold, but the government pays a bounty of ten shillings for each one killed.*

Five days later they had arrived in the western portion of present-day Caldwell County, at the very foot of the Blue Ridge escarpment, where the piedmont merges into the mountains of Western North Carolina. Spangenberg confided to his diary: "We are here in a region that has perhaps been seldom visited since the creation of the world. We are some 70 or 80 miles from the last settlement in North Carolina, and have come over terrible mountains, and often through very dangerous ways."

But things were about to become more challenging—so much so, in fact, that Spangenberg did not make another diary entry until December 5, in which he described the Moravians' adventures in the real mountains:

> *We have reached here after a hard journey over very high, terrible, mountains and cliffs. A hunter, whom we had taken to show us the way, and who once knew the path to the Atkin [Yadkin River], missed the trail, and led us into a place from where there was no way out except by climbing an indescribably steep mountain. Part of the way we climbed on hands*

and knees, dragging after us the loads we had taken from the backs of the horses, for had we not unsaddled them they would have fallen backwards down the mountain—indeed, this did happen once; part of the way we led the horses, who were trembling like a leaf. When we reached the top we saw mountains to right and to left, before and behind us, many hundreds of mountains, rising like great waves in a storm. [They had passed up to the headwaters of the Johns River in present-day Caldwell County and reached the crest of the Blue Ridge, a mile or so northeast of Grandfather Mountain and a similar distance southwest of Blowing Rock in present-day Watauga County.] We rested a little, and then began to descend, not quite so precipitately. Soon we found water, and oh, how refreshing it was! Then we sought pasturage for our horses, riding a long way, and well into the night, but found nothing except dry leaves. We could have wept for pity for the poor beasts. It had become so dark that we could not put up the tent, and were obliged to camp under the trees. It was a trying night! In the morning we went further, but had to cut our way through laurel bushes and beaver dams, which greatly wearied our company...Next day we went on, and came to a creek, so full of rocks that we could not follow it, and with banks so steep that a horse could not climb them, and scarcely a man. That evening we put up our tent, but had barely finished when there came such a wind storm that we could hardly stand against it. I think I have never felt a winter wind so strong and so cold. The ground was covered with snow; water froze beside the fire. Then our men lost heart! What should we do? Our horses would die, and we with them. For the hunters had about concluded that we were across the crest of the Blue Mountains, and on the Mississippi watershed. The next day the sun came out, and the days were warmer, though the nights still very cold. Brother Antes and I rode over the tract, and think that it contains about 5000 acres. [This tract encompassed lands in which the present-day city of Boone is located.]

By December 14, the Moravian party had exited Western North Carolina and camped on the Yadkin River. With time and leisure to catch up on his diary entries, Spangenberg provided one last entry regarding their memorable sojourn:

Here we are at last, after a difficult journey among the mountains. We were completely lost, and whichever way we turned we were walled in. Not one of our company had ever been there before, and path or trail were unknown—though how can one speak of path or trail when none existed? We crossed only dry mountains and dry valleys, and when for several days we followed the river in the hope that it would lead us out we found ourselves only deeper in the wilderness, for the river [the New River and its tributaries] ran now north, now south, now east, now west, in short to all points of the compass! Finally we decided to leave the river and take a course between east and south, crossing the mountains as best we could. One height rose behind the other, and we traveled between hope and fear, distressed for our horses, which had nothing to eat. At last we reached a stream [the Lewis Fork of the Yadkin River, about twenty miles northeast of Blowing Rock] flowing rapidly down the mountain, followed it, and happily reached this side of the Blue Ridge. We also found pasturage for our horses, and oh, how glad we were!

In October 1753, fifteen Moravians were chosen to leave Pennsylvania and journey to the backcountry lands in North Carolina that the Moravians had surveyed and now owned. They picked a surveyed tract called Wachau (later Wachovia) in the piedmont where present-day Winston-Salem is now situated. On Spangenberg's advice—based, after all, on actual experience—they had chosen to avoid settling in the mountains to the west or even very near them. But the bishop's diary—now available in print and on the Internet—contained the first extended observations about the mountainous terrain and the animals of Western North Carolina.

John Fraser and the Economics of Plant Exploration

The economic considerations behind the botanical exploration of the southern mountains have been generally neglected. It's a cliché, but true, that it's money and competition that make the world go around. An almost insatiable desire on the part of Europeans—especially in England—for American plants emerged during the late eighteenth century. There was even a faddish vogue that involved growing North American species together in areas designated as American gardens.

New publications like the *Botanical Magazine, or Flower Garden Displayed*, which featured hand-colored plates, found a ready audience of home gardeners in England who were motivated to acquire a variety of American plants. Accordingly, commercial nurseries were founded that vied with one another for the introduction of choice plants. The point men for the nursery owners were the plant collectors who traveled far and wide in a competitive hunt for new plants.

John Fraser (1750–1811), a Scotsman from Inverness-shire, was one of the European plant hunters most closely associated with the southern mountains in general and with Western North Carolina in particular. Andrew Michaux, his competitor in the southern mountains, is perhaps better known, but Fraser—who studied Michaux's collecting methods firsthand—was almost equally adept at discovering and/or introducing scores of mountain plants into horticulture.

Fraser acquired an interest in plants at the Chelsea Physic Garden in London. Plans for an initial collecting trip to Newfoundland were encouraged and perhaps

financed in part by William Aiton, head gardener of Kew Gardens, and Sir James Smith, president of the Linnean Society of London.

Thereafter, utilizing the port city of Charleston, South Carolina, as his home base, Fraser visited the southern mountains, including sites in Western North Carolina, on numerous occasions during the years from 1786 to 1807. He was renowned for his expertise at successfully shipping plants to the European continent and England, where he established a profitable nursery at Sloane Square, Chelsea. It's been speculated that he may have initiated the practice of utilizing the moisture-holding properties of sphagnum moss as packing material.

His plants were sold far and wide, including a collection that Empress Catherine of Russia purchased in 1796 for her garden in Saint Petersburg. This relationship was expanded when Fraser was subsequently named botanical collector for Russia. He died in 1811 as a result of a fall from his horse.

The most famous of the Scottish botanist's plants today are the Fraser magnolia (*Magnolia fraseri*), the Fraser fir (*Abies fraseri*) and the purple rhododendron (*Rhododendron catawbiense*). The beautiful Fraser magnolia is the most common of the three deciduous magnolias native to Western North Carolina. The Fraser fir is an endemic species in the southern mountains, being restricted to the highest elevations of southwestern Virginia, East Tennessee, and Western North Carolina. As the Christmas tree of choice throughout the southeastern United States, it plays a significant role in Western North Carolina's multimillion-dollar ornamental plant industry.

The honor for discovering the purple rhododendron goes to Michaux. But it was Fraser who first promoted its horticultural use in England. Accompanied by his son, John, he initially encountered the plant on Roan Mountain during his last foray to North America in 1807. By 1809 nurserymen and gardeners in England were experimenting with living plants of this wonderful shrub.

The long-reaching results of this experimentation are described by Stephen A. Spongberg, horticultural taxonomist with the Arnold Arboretum in Massachusetts, in his *Reunion of Trees: The Discovery of Exotic Plants and Their Introduction into North American and European Landscapes* (1990): "Once in the hands of English horticulturists, this hardy Appalachian species provided a genetic matrix that was quickly appreciated by plant breeders, and a raft of garden hybrids...were produced. This group, frequently referred to simply as '*catawbiense* hybrids'—or 'iron clads' owing to their hardiness—has provided cold-tolerant cultivars with flowers that range in color from creamy white and pink through crimson to deep, bluish purple."

These cold-tolerant hybrids of our native purple rhododendron returned to America as cultivars that could then be marketed far and wide, including such profitable areas as New England and other northern climes. As previously noted, it's money and competition that make the world go around, especially when it involved the early plant exploration of the southern mountains.

Mountain Ornithologist:
John S. Cairns

The systematic observation of the birds of Western North Carolina did not commence until May 22, 1885. That's the day Harvard professor William Brewster stepped off a coach of the Western North Carolina Railroad in Asheville.

One of the foremost figures in the history of American ornithology, Brewster proceeded to conduct a breeding-bird survey of the Balsams, the Cowees, the Highlands plateau and Mount Mitchell that's described in detail by Marcus B. Simpson Jr. in his 1980 article "William Brewster's Exploration of the Southern Appalachian Mountains: The Journal of 1885." During this venture, Brewster verified the existence of numerous breeding birds in the high southern mountains (rose-breasted grosbeaks, Blackburnian warblers, etc.) that had previously been presumed to breed only many hundreds of miles to the north. He also observed that two of the birds breeding here—the blue-headed vireo (then called the solitary vireo) and the dark-eyed junco—were different enough from the northern species to be described taxonomically as Southern Appalachian subspecies.

While exploring Western North Carolina in 1885, Brewster did not know there was a resident lay ornithologist living at Weaverville, several miles north of Asheville—one who had been conducting year-round observations on his own initiative. His name was John S. Cairns. He was twenty-three years old. And he, too, had a passion for birds.

When Brewster saw a paper titled "The Summer Birds of Buncombe County, North Carolina" that Cairns contributed in 1889 to an ornithological journal, he wrote the young birder, thereby initiating a correspondence that lasted until Cairns's untimely death in 1895. The eminent Harvard professor and the

business manager of the family-owned Reems Creek Woolen Mills had found common ground.

Cairns's parents migrated in 1855 from Scotland to the United States, where the elder Cairns served as foreman of various textile mills in New England. The family moved to Buncombe County in 1870. In 1888, John married Lena Cressman at Haw Creek Episcopal Church. In 1907, twelve years after Cairns's tragic death (his gun accidentally discharged in the Black Mountains), Lena became the second wife of author William Sydney Porter ("O. Henry").

No one seems to know just how or why Cairns developed his knowledge of birds. But it was considerable. Simpson summarized Cairns's accomplishments in a profile written for the *Dictionary of North Carolina Biography* in 1979: "His observations provided the best available description of the avifauna of the North Carolina mountains before extensive disruption of the original forests by human activities. He added over a dozen bird species to the state list…Many of his four thousand bird and egg specimens were added to zoological collections."

I have in my library an eighteen-page pamphlet titled *List of the Birds of Buncombe County, North Carolina* that Cairns published privately in 1891. It is the best record available as to how much the bird life of Western North Carolina has changed in just over a century: Bewick's wrens were then "common" (now rarely seen); a flock of forty pelicans appeared on the French Broad in May 1889; American bitterns were then "tolerably common" (now only very occasional); black rails nested in the wet meadows along the rivers (scarcely ever seen again); swallow-tailed kites were seen each season (now very rarely seen); golden eagles were breeding "on the cliffs" (their status today is uncertain, but they're certainly not a breeding species as of now); barn swallows were then "rare" (now very common); warbling vireos were "tolerably common" (now only occasional) and so on.

The specimens of birds, eggs and nests that Cairns shipped to Brewster complemented the professional ornithologist's personal observations and helped lay the foundation for our present understanding of the birds of the southern mountains in general and Western North Carolina in particular. For anyone residing in Western North Carolina with an interest in birds, the correspondence between Brewster and Cairns is both informative and delightful. It was edited by Simpson and published in 1978 as "The Letters of John S. Cairns to William Brewster, 1887–1895." Here's a typical letter, dated "Weaverville, N.C. June 16 1887":

> *Dear Sir: In regard to nest of Mtn S.V. [i.e., solitary vireo, now named blue-headed vireo] you may describe it if you wish [i.e., the first nest of this subspecies ever collected]. The nest was found on the south side of the Mtn about 200 feet from the top, in a beautiful grove of Beech and Chestnut timber. I seen an other pair, but could not find their nest. Will try and go to the Black Mtn this month. I heard and seen a number of Thrushes when on Craggy, but none like the one I got last year. The weather was very cold and windy their and the birds did not seem to be on the move, and very shy…Mean while I will do my best for you here and get to the mts soon as I can…Yours truly, Jno. S. Cairns*

In 1897, Cairns became the first North Carolina resident to have a bird species named in his honor. The Cairns warbler (*Dendroica caerulescens cairnsi*) is a subspecies of the black-throated blue warbler that nests only in the high mountains of Western North Carolina and adjacent regions. I never see this beautiful bird without thinking about the young John S. Cairns, his friendship with the Harvard professor and his passion for the birds of the North Carolina highlands.

Park Naturalist:
Arthur Stupka

It's probable that the most influential naturalist—in regard to fieldwork, teaching and writing—yet produced in the Great Smokies region of East Tennessee and Western North Carolina was Arthur Stupka. He was the first naturalist in the National Park Service in the eastern United States. That was at Arcadia National Park in Maine, shortly before he became chief naturalist in the newly founded Great Smoky Mountains National Park in 1935. Stupka held that position for twenty-five years before becoming the official park biologist for another four years. Upon "retiring," he continued to write and conduct natural history workshops—his uniquely styled, leisurely paced but intensely informative talks, walks and tours—until his death in 1999.

According to Margaret Lynn Brown, in *The Wild East: A Biography of the Great Smoky Mountains* (2000), Stupka met with J. Ross Eakin, the first superintendent of the national park, shortly after reporting for duty. Eakin, then preoccupied with overseeing Civilian Conservation Corps projects, exclaimed: "'I don't need a naturalist because I don't want any more visitors [until construction is finished].' And so Eakin told Stupka to get acquainted with the park: 'This is your baby,' he said. Stupka spent four years hiking, observing, recording, building the park's natural history collection, and making connections with scientists before he offered a single public hike or evening program."

Many years later, he told this writer: "You know, I was actually a pretty fortunate fellow. I was first on the scene, which was important, and then Eakin instructed me to be my own boss, which was a godsend. It was a great opportunity, and I tried to make the best of it." And he did.

In his *Museum Curatorship in the National Park Service, 1904–1982*, published by the Department of the Interior in 1993, Ralph H. Lewis prescribed methods of organization for natural history collections in the national park system. Therein, Lewis detailed—as an example that present-day park naturalists might emulate—just how active and thoroughgoing Stupka was during this early period: "For the next three and a half years he studied intensively in the area he would later interpret. With notebook and altimeter constantly at hand, he probed particularly how the animals and plants of the GSMNP related in distribution and life histories to the varied topography. His carefully organized field notes represented an especially valuable contribution."

Stupka's energy attracted the attention of countless scientists and their students, who came to the park on an annual basis to study and categorize its natural assets. According to Lewis, Stupka and his associates were eventually able to pass along an herbarium of pressed plants that exceeded 6,000 specimens; 375 mammal skins and skulls; 55 bird skins; a reptile series of 300 snakes, 34 turtles and 73 lizards preserved in fluid; an amphibian collection of more than 100 salamanders, 163 frogs and 136 toads in fluid and a series of pinned insects numbering almost 10,000. More important than the number of specimens collected was the data associated with each specimen, detailing who made the collection as well as precise information on when and where (place, habitat and altitude) each was collected. As unfortunate as it might seem to some that so many plants and animals were collected, it must be remembered that without a range of specimens and accurate data as to their distribution, the bulk of the flora and fauna in the national park couldn't have been properly assessed and protected.

According to Brown, Stupka refused to participate when the park superintendent told him in 1960 that the newly formed Natural History Association "must sell books and postcards to help finance the park." He later recalled that "I no longer wanted to be the naturalist." Instead, he shifted positions and became the park biologist because "I didn't want to have anything to do with financial things." But he continued for the following thirty years, until almost the very day of his death, to conduct walks and evening talks for free.

It was my pleasure to have first met Arthur in the early 1970s at the Hemlock Inn near Bryson City, where after his "retirement," he spent parts of every year as the guest of innkeepers John and Ella Jo Shell. (The other part of the year was spent in either Gatlinburg or Florida.) At the inn he was a magnetic draw for those interested in natural history in general and in the flora, fauna, geology and natural areas of the national park in particular. His delightful slide programs, nature walks and motor tours were legendary.

Arthur was, in some ways, a peculiar fellow, in the best sense of the word. He could be most affable and confiding if he liked and trusted someone. But he was rather formal and of the old school in most matters, especially those pertaining to natural history, and he didn't tolerate fools. If for whatever reason he didn't take to someone, his conversation quickly dried up, and before long he would disappear.

I was one of the lucky ones. Arthur and I got along from the moment of our initial introduction by John Shell. We didn't become intimate friends, but we always

had things to talk about whenever we met. And on several occasions we went for little nature walks in park areas adjacent to the Hemlock Inn.

Like all close observers of the natural world, Arthur didn't hurry. He sort of moseyed along—almost, at times, at a snail's pace. He was interested in just about everything that came into view, from lichens and liverworts to toads and hawks. Unless asked, he never had a whole lot to say about such entities. But when queried, he became an unforgettable source of information delivered in a crisp, exacting manner. From this listener's point of view, he tended to talk too little rather than too much.

I knew that I was OK with Arthur the day he led me to the most luxuriant stand of walking fern I've ever encountered inside the park. In a remote, shady ravine leading up from Deep Creek, a colony of dainty, outreaching, lance-shaped blades covered a huge boulder in an intertwined mat of emerald green fronds.

"Now, isn't that something?" Arthur exclaimed, his eyes twinkling. "Walking fern is my favorite fern. Promise that you won't ever bring anyone here that you don't trust. They might want to come back and steal them."

Arthur was especially protective of the park's flora. He once summed up the lure of the annual Spring Wildflower Pilgrimage held in Gatlinburg, Tennessee, each year in this manner: "Vegetation is to the Great Smoky Mountains National Park what granite domes are to Yosemite, geysers are to Yellowstone and sculptured pinnacles are to Bryce Canyon National Park."

On the one hand, Arthur didn't want native plants extracted from the park; on the other, he didn't want plants introduced that weren't a part of the original Smokies flora—not even plants that were showy and famous. He was rightly a purist in that regard. Accordingly, he became infuriated when a botanist at the Highlands Biological Station offered him a stand of oconee bells (*Shortia galacifolia*) to transplant into the park, where it had never been. Thirty or so years after the incident, he still became incensed while telling me the story.

One of the last times that I saw Arthur, at a science conference held in the park headquarters building near Gatlinburg, I started quizzing him about the dates of arrival and departure for migrant birds in the park. He was, after all, the first authority on the avifauna of the Smokies, having maintained detailed field notes on such matters year after year, which were published in 1963 as *Notes on the Birds of Great Smoky Mountains National Park*.

But I could tell that he didn't have his heart in the conversation. After a while, he looked at me and said, "Since I can't hear them anymore, I don't enjoy the birds so much as I once did."

Arthur's literary output on the flora and fauna of the national park included separate volumes devoted to birds and amphibians as well as a single one covering woody plants (trees, shrubs and vines). These aren't identification guides but detailed observations on each plant or animal species as to habitat, seasonal variation and distribution—all based on his careful journal entries or, occasionally, upon observations made by fellow naturalists he trusted.

Arthur was for the most part, in my experience, a reticent man, but he would from time to time express his deep emotional attachment to the natural world in an almost poetic manner. For instance, in his "Through the Year in the Smokies," a splendid month-by-month essay contributed to a volume edited by Roderick Peattie titled *The Great Smokies and the Blue Ridge* (1943), he described the flight of ravens in this manner:

> *A strong flier, the raven is capable of remarkable performances on the wing. Once, in March, while at Collins Gap high up on the crest of the Smokies, I watched what may have been a mated pair come into view. Flying side by side, the two performed a series of thrilling acrobatics involving dipping, sailing, rolling (head foremost, as well as sideways), and plunging—all executed simultaneously and in the most finished manner...For fully five minutes I had them in good view. Once they tumbled down together into the dense forest. Finally I lost them when, in a series of power dives, they disappeared from sight far below.*

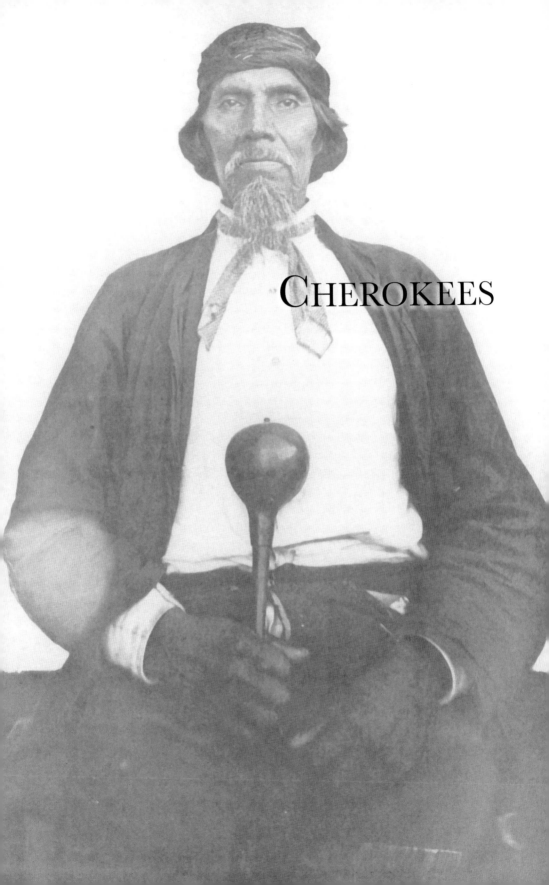

CHEROKEES

Ancient Fishing Strategies

During either natural history workshops or presentations regarding Cherokee history and culture, I'm sometimes asked if the prehistoric Cherokees used any sort of poison on their blowgun darts, as did the native populations of Central and South America. The darts made by the Cherokees (slivers of black locust, hickory or white oak) were from ten to twenty inches long, with thistledown tied at one end to form an air seal in the blowgun, which was a hollowed piece of cane cut to a length of seven to nine feet. The Cherokees were very accurate with these weapons, up to seventy-five or so feet, when hunting birds and small mammals. But there is no evidence that they used poisons of any sort on their darts.

They did, however, routinely employ poisons from several native plants when fishing. The drugging of fish was practiced during the dry months of late summer and early fall when water flow in mountain streams is often low, thereby creating a series of small pools with high concentrations of fish.

The two plants commonly used to stupefy fish were yellow buckeye (*Aesculus octandra*) and goat's-rue (*Tephrosia virginica*), also known as devil's shoestring or catgut. The toxins in these plants temporarily destabilized a fish's nervous system, causing it to float to the surface of the water, where it was easily collected in a long-handled basket made for that purpose. I do not know if these toxins posed a health risk to the humans eating the fish.

The Cherokees and other American Indian tribes in the southeastern United States collected buckeye nuts or entire goat's-rue plants and ground them up on the tops of posts resting on the bottom of a pool. The poison released into the water by the nuts was esculin, a glucoside used in skin-protection lotions. The

toxic substance in goat's-rue is rotenone, a principal ingredient in various modern insecticides and fish poisons. Goat's-rue is less well known than buckeye. It is, however, common in open or waste areas throughout Western North Carolina. A silky-haired plant standing about one to two feet high, it can be recognized by its highly dissected leaves (seventeen to twenty-nine small leaflets per leaf) and its bicolored, irregularly shaped flowers (yellow base, pink wings), which blossom throughout the summer months.

The ancient Cherokees also speared fish, caught them with lines and bone hooks, shot them with bows and arrows and grabbed them with their bare hands. But their most productive strategy involved the use of giant rock weirs (fish traps) contrived from boulders and smaller rocks. Located throughout the southern mountain region, wherever the Cherokees situated their large villages in large bottomlands alongside major streams, these structures allowed for huge quantities of fish to be taken at one time.

They were constructed from bank to bank where the water was swift. Two converging, waist-high, wall-like alignments formed a V-shape, with an opening at the apex of the V. Facing downstream, the V-shaped structure funneled fish into a wicker or log trap situated at the opening. Harvesting the fish swept into the traps was a piece of cake. The Cherokees especially liked to capture freshwater catfish, which were cleaned but not skinned and then smoked over an open fire. The smoked-and-dried catfish provided a valuable source of protein during the winter months. When the catch was heavy, they made "a town feast, or feast of love, of which everyone partakes in a most social manner, and afterwards they dance together," recorded the eighteenth-century Cherokee trader and historian James Adair in his *History of the American Indians*, first published in 1775.

The white settlers who replaced the Cherokees were not so foolish as to let the productive fish traps go to waste. They sometimes built their own, but for the most part they used those that their American Indian predecessors had constructed. One of the most accessible of these ancient traps is located in the Little Tennessee River alongside NC 28, about five miles north of Franklin. Back in the 1980s, I visited with Robert T. Bryson to discuss the trap. He was then eighty-three years of age, having been born near the site of the trap in the Cowee Community of Macon County in 1904.

Consulting the family bible, in which information had been recorded for generations, Mr. Bryson noted that his ancestors "came into the Little Tennessee region in the 1820s and began using the trap at that time. My father and I were still gathering fish from the sixty-five-yard-wide trap on up until 1920. The water was always high back when I was a boy. Dad and I would take a boat out to check the trap. Mainly we'd catch fish in the spring when they were running. We caught a lot. Grandmother would sometimes try to dry the surplus, but mainly we shared them with the neighbors. One day Dad and I caught a fish whose tail still touched the ground when he held it up at eye level. It may have been a catfish. That's the truth, not a fish story."

Sochan and Other Wild Greens

There was a time not so very long ago when just about everyone made it through the winter on cured meats, stored roots and canned or dried vegetables. Using time-honored procedures, locals avidly sought after and prepared the first wild greens that appeared each spring. Even in this age of supermarkets and year-round produce, many of us still look forward to locating, harvesting, preparing and then chowing down on the real thing.

"A timely mess of wild greens will cure most of what ails you," a countrywoman of my acquaintance who lived into her nineties used to say.

The gathering of wild greens here in the southern mountains began, of course, with the earliest American Indians, who penetrated the region more than ten thousands years ago. They brought with them an extensive knowledge of plants used in other areas and developed a keen eye for the new ones that grew here. Can you imagine, after a long, hard winter in a rock shelter, how they must have anticipated the first tangy spring greens?

Bruce Smith, an archaeologist at the Smithsonian's National Museum of Natural History, has established in his *Emergence of Agriculture* (1995) that the farming economy of the early North American Indians wasn't based on maize but on selected wild plants maintained in areas adjacent to villages. There was a systematic use of wild greens, gourds, sunflowers and smartweeds thousands of years before maize was introduced.

Older members of the remnant Eastern Band of Cherokees here in Western North Carolina still know and use the wild greens their ancestors gathered and ate

as fresh greens or as potherbs (cooked greens). They enjoy locating, preparing and eating the greens, of course, but in doing so they are also consciously keeping alive an important part of their cultural heritage.

"Before there were many cars the old folks used to walk all over the mountains gathering greens," tribal member Lucinda Reed told me before her death several years ago. "You can eat off the land all year round if you want to."

Four of the favorite wild greens of the Cherokees (branch lettuce, poke, ramps and sochan) are discussed in some detail below. But if you attend a community club potluck in the spring on reservation lands, there's every chance you'll also have an opportunity to try other wild greens, like rose twisted-stalk, small-flowered phacelia, Solomon's-seal and spiderwort, which are collected as young plants, cleaned and then parboiled or fried or both.

Branch lettuce (*Saxifraga micranthidifolia*), sometimes called wild lettuce, bear lettuce or lettuce saxifrage, grows on wet banks and in seepage areas and streams. Each basal rosette contains several toothed leaves from four to twelve inches long. Eat raw with a salad dressing. It's also good with a little vinegar and chopped onions. To make it really good, drizzle on some hot bacon grease to wilt the greens. The Cherokees often boil and then fry their branch lettuce with ramps.

Poke (*Phytolacca americana*) is also called poke sallet (or salad), pokeweed, poke greens, pocan, pigeonberry and inkberry. It can be found in abundance in open fields and along roadsides. (Note that poke contains several toxic compounds. Never eat poke without first parboiling it at least three times in separate changes of water. Do not include part of the root when collecting. Discard any shoots tinged with red.) The Cherokees prepare shoots no more than eight inches long in a number of ways: like asparagus; cut and fried golden brown in a cornmeal batter like okra or cut up with scrambled eggs.

Ramps (*Allium tricoccum*), also called wild leeks, are found growing on rich, wooded slopes in the heart of the southern mountains but not in adjacent piedmont areas. They are sometimes available at roadside stands. After ginseng, ramps are the second most famous plant harvested in Western North Carolina. There's even a ramp festival held in its honor every spring in Waynesville. The plant, which belongs to the same genus as the domesticated onion, has gained a wide reputation for having a powerful taste and a lingering odor that has discouraged the fainthearted from enjoying this succulent treat. What's all the fuss about? They're delectable. The Cherokees eat the bulbs and stems raw, or they cook and mix them with other greens or with scrambled eggs.

Sochan (*Rudbeckia laciniata*), known as green-headed coneflower by non-American Indians, is one of the most prized spring greens the Cherokees gather. They sometimes call it *so-cha-ni*, with the accent on the last syllable. Their gardens often have semicultivated patches of the plant in damp, protected areas. Closely related to black-eyed Susan (*Rudbeckia hirta*), sochan grows to ten feet tall in wet

areas and along damp woodland borders. The flower heads that appear in mid-summer are about three inches wide with drooping yellow rays and a center disk that's greenish-yellow. The Cherokees recognize sochan as soon as it comes out of the ground in mid-spring by its distinctively lobed leaves and by its smell. They boil the young shoots and leaves with several changes of water. Prepared in this manner, sochan has a chewy texture and zesty flavor. It's even good cold as a snack with a little vinegar added. In the opinion of many—this writer included—sochan is the very finest of the traditional potherbs gathered in the southern mountains.

"I find sochan mainly along streams," Lucinda Reed said. "I parboil it and rinse it twice. Then I cook it with fat and eat it just like it is. My husband loves it, but I don't cook it so much anymore because it sometimes gives me heartburn. If I cooked sochan for him, I'd just have to eat it myself.

"Poke sallet is good, too," she added. "After you parboil and rinse it, you cook it just like sochan. I always scramble eggs with my poke."

You can also quarter the stalk and cook it like fish.

"I prepare ramps pretty much the same way by chopping and adding eggs," she continued. "A friend of mine wilts hers by dropping the entire cleaned plant—bulb, stalk and leaves—into hot grease so that, when ready, it's crunchy."

Mrs. Reed refused to pick a favorite traditional Cherokee wild green.

"If I had my choice of all of them, I'd just have to take a dab of each," she remarked. "They're all good."

Booger Masks:
Cherokee Mirrors

"We all wear masks
Painted red cheeks, manic grins.
Wood, clay, paint—show the world what it wants.
But masks are mirrors, too.
A one-way window between us,
But never my way, never yours.
We only see reflections.
You can see through, though, if you're close enough.
See the worlds behind the mirror."

From an untitled and anonymous poem

A mask can be defined as a mechanism employed to cover the face as a protective screen or disguise. For protection, they have been utilized by medieval horsemen, welders, fencers and hockey goalies, among others. Their most intriguing uses, however, have been as devices of disguise, as in a theatrical production or as part of the paraphernalia of a religious and/or cultural ritual.

We don't have to go to darkest Africa or the remote jungles of South America to find recent and extensive uses of a variety of masks in this latter context. They are to this day an important element in Cherokee rituals.

A visit to the Qualla Arts and Crafts Mutual, or other outlets in Cherokee, will turn up a variety of the contemporary masks being produced by the reservation's

remarkable craftspeople. They sometimes use skins or gourds, but for the most part masks are carved from buckeye or other suitable wood and then colored with natural dyes, paint, clay, charcoal or shoe polish.

Often these modern masks simply depict a man with horns (the buffalo mask) or maybe a bear's face. I am especially attracted to those haunting masks that are presented unadorned as a skull-like rendering. A favorite theme of some carvers is that of a man's head topped by a coiled rattlesnake. And then there are those grotesque or sometimes even obscene productions known as booger masks.

If you take the time to talk with a Cherokee mask maker, you'll get a friendly enough reception (especially if you're actually shopping for a mask), but you're not likely to get much insight into their themes. These people just don't make their living talking. They'll say something like, "Oh, that's just a snake that happens to be on that man's head," or "Funny thing, I started in to carving and it just turned out that way," or "You think it looks like a what?"

Unless you happen upon an unusually talkative mask maker in an unguarded moment, your best sources for detailed information on the Cherokee mask tradition are the book-length study *Cherokee Dance and Drama* (1951), by Frank G. Speck and Leonard Broom, and the article by Raymond D. Fogelson and Amelia B. Walker titled "Self and Other in Cherokee Booger Masks," which appeared in the *Journal of Cherokee Studies* in 1980.

Cherokee Dance and Drama was written in collaboration with Cherokee mask maker and cultural authority Will West Long. Others who contributed to the book were Long's elder sister, Roxy, his elder half-brother Lawyer Calhoun, Deliski Climbing Bear, and Mrs. Sampson Owl. This book is the real thing.

Will West Long, the son of Sally Terrapin and John Long, a Baptist minister, was born about 1870 in the traditional Big Cove section of the Qualla Boundary, which is the official name for the community normally referred to today as Cherokee. After attending a school near High Point, he returned to Cherokee at the time the pioneering anthropologist James Mooney was there collecting data for his classic study published in 1900 as *Myths of the Cherokee*. Until he learned how to read, write and speak the Cherokee language for himself, Mooney hired Long as a scribe and interpreter. Prompted by Mooney, Long later attended Hampton Institute and lived in New England until he was in his mid-thirties. Just before his mother died in 1904, he returned home, married and spent the remainder of his life there.

His mother's interest in such matters, along with Mooney's influence, created in Long a passion for preserving the quickly fading history and social customs of his people. He collected materials and insights that would otherwise have been lost. Almost single-handedly, he helped maintain the traditional dances and the fine art of making traditional masks. Swimmer, Mooney's primary informant, was the greatest and most influential Cherokee shaman of the entire historical period, but Will West Long was the tribe's greatest and most influential shaman of the

twentieth. They are towering figures in the annals of Cherokee cultural history.

As described in the sources cited earlier, the Booger Dance (also called the Mask Dance) was a ritual performed after the first frost. It featured masks that exaggerated human features; that is, they represented racial types: American Indian man (a dark red face); American Indian woman (light red face with paint on cheeks); white man (woodchuck or opossum fur as a beard); black man (charcoal colored) and so on.

What made the booger masks exceptional were the frequently grotesque, often humorous and sometimes obscene elements incorporated into them that suggested European features like bushy eyebrows, mustaches, chin whiskers, big noses, ghastly white pallor and bald heads. The boogers—usually depicted as older men— represented "people from far away or across the water"; that is, Europeans, blacks, northerners, southerners or alien Indians, who intruded upon the peaceful social occasions of the Cherokees. Upon entering the dance house, they broke wind, chased the women and generally behaved as barbarians. Asked what they wanted, the boogers first replied, "Girls!" and then announced that they wanted "To fight!" Instead of reciprocating, the Cherokees allowed them to dance out their hostilities.

These rituals have been interpreted in several ways. For Fogelson and Walker, who is Cherokee, it was a way to deal with "the harmful powers of alien tribes and races, who, as living beings or ghosts may be responsible for sickness or misfortune." It also served as "a condensation of the acculturation process as seen from the Cherokee perspective: first the white man tried to steal women; second he wanted to fight; and then, finally, he was satisfied to make a fool of himself."

It's also clear that many of the ingeniously crafted masks used in the ceremony simply poked fun at boorish masculine traits in general, including the "excessive preoccupation with sexuality" (the booger masks didn't feature large noses by chance) and the desire to be "in charge."

So, remember that masks are often mirrors. The next time you spot a Cherokee booger mask in a shop, at one of the craft festivals or in a museum, pause and take a closer look. It just might be yourself that you're looking at.

Masters of the Night:
Cherokee Owl and Witch Lore

The ancient Cherokees were astute observers of the natural world. The mountain landscape and all of its plants and animals were a part of their spiritual cosmos, especially the birds.

Their spiritual system divided the world into three levels. The Upper World, represented by the birds, was the realm of light, goodness and eternal life. The Under World, represented by the serpents, was the realm of darkness, evil and eternal death. By balancing these opposing realms, the Cherokees sought to bring peace, harmony and stability into the Middle World, the mundane everyday realm within which humans reside.

There is a great deal of serpent imagery in Cherokee lore, especially that having to do with the Uktena, a giant, mythic snake that haunted the Under World. But the main portion of their animal imagery is devoted to birds. For Cherokees, the birds were magical entities that could do something humans could only dream about: fly.

Most Cherokee bird lore is concerned with the species they saw on an everyday basis: cardinals, chickadees, tufted titmice and so on. The myths and stories concerning birds are usually rather lighthearted, but not all of them. At times they associated birds with the negative aspects of the Under World. The most logical candidates for this distinction were the owls, those woeful denizens of the darkness.

There are five owl species that appear with regularity here in the southern mountains: great-horned owls, barred owls, screech owls, barn owls and saw-whet owls. The Cherokees no doubt observed all of these, but their recorded lore gives

names to but three. *Tsgili* is the great-horned owl, which many know as the hoot owl because of its hooting calls. The barred owl is *uguku*, an onomatopoetic word that mimics the bird's "Who cooks for you?" call. *Wahuhi*, for the screech owl, is also onomatopoetic in that it mimics the bird's whinnying call.

Owls appear in differing contexts within Cherokee lore. The screech owl was often a messenger of future events. Owls in general were associated with warfare. When on the war trail, the ancient Cherokees, a hypersuperstitious people, divined the future outcome of a conflict according to screech owl calls. If heard on the right or left, the call signified that the Cherokees would be victorious. If heard ahead or behind, the call signified defeat, in which instance they would cancel the expedition. Owl calls were also used as a means of communication by scouts at night.

Anthropologist James Mooney, who lived with the Cherokees on the Qualla Boundary (present-day Cherokee) during the late 1880s, observed in his *Myths of the Cherokee* (1900) that "Owls and other night-crying birds are believed to be embodied ghosts or disguised witches, and their cry is dreaded as a sound of evil omen." Of the three owls named in Cherokee lore, the great-horned owl was by far the most dreaded; indeed, the designation *tsgili* was expanded in meaning so as to signify "witch." Both the great-horned owls and the witches (in which the Cherokees firmly believed) indulged their mysterious powers only in darkness. They were the masters of the night.

The great-horned owl was held in such regard for good reason. Aptly known as "the Tiger of the Night," this predator, which can stand more than two feet tall, with a wingspan of four and a half feet, has ice-tong-like talons that can rip through a fencing mask. It will hunt by day but is supremely equipped for night stalking. Its eyes are thirty-five times more sensitive than those of a human being, so powerful that they can capture prey in light so dim it is the equivalent of a candle burning in the dark nearly half a mile away. Specialized wing feathers, fringed with down like a butterfly's, enable this predator to move silently in flight. No sound of rushing wings warns the victim of the devastating strike that's about to be delivered.

The Cherokee witches admired and were associated with these qualities in numerous ways. I have always been struck by the sacred formulas (chants, incantations or poems) that the Cherokee medicine men used to create good luck in hunting or warfare, in healing or in affairs of the heart. The evil medicine men or witches used the sacred formulas to accomplish their own nefarious ends.

One such category of these formulas has been labeled "To Lower One's Soul" by Alan Kilpatrick, a member of the Cherokee Nation in Oklahoma. In *The Night Has a Naked Soul: Witchcraft and Sorcery among the Western Cherokee* (1997), Kilpatrick stated that the Cherokee sacred formulas that fall into this category "represent instruments whose express purpose is to destroy human life. Because of their grave and irreversible consequences, life-threatening spells...were traditionally the last incantations to be

taught an apprentice." Here's a sacred formula from Kilpatrick's "To Lower One's Soul" category that I've rendered from one of his literal translations. No reader will be surprised at this point to see which bird is invoked:

To My Enemy

Your name is night.
I am the black owl
that hunts the darkness
for your heart and soul.
Your name is the night.
I am the black owl
hunting your soul.

Nantahala Indian Caves

Throughout Western North Carolina there are special places where there's a confluence of the natural world with ongoing human uses and events. I like to explore the places where these forces intersect and interact. They aren't hard to find. Take, for instance, the Nantahala Gorge, that modern-day epicenter of the whitewater industry situated ten or so miles west of Bryson City.

The Nantahala Gorge was in one sense a "chasm of horrors" to the ancient Cherokees—so much so, indeed, that they associated the place in their legends with four mythic monsters, most especially with the Uktena, a mythic serpent from the dreaded Under World. Of gigantic proportions, more than thirty feet long and as big around as a tree trunk, this monster displayed a flashing quartz crystal embedded in its forehead that attracted humans to certain death like moths to a flame. Such associations exemplified an atmosphere of gloom and sinister foreboding that one can still feel in the Nantahala Gorge, especially in winter.

There's little doubt that the ancient Cherokees knew the extensive cave systems that occupy the slopes in the marble-limestone-talc formations that run eight miles from the present-day raft put-in to Wesser, where the Nantahala Outdoor Center is located. Indeed, it's not unlikely that they penetrated these systems more fully than is now feasible after 150 or so years of blasting by various mining operations. The caves known as Flowstone, Lost Nantahala, Flint Ridge, Blowout Springs, Old Timbers, Talc Mountain Blowing Cave and others may in places form a connected cavern system. It's rumored that the largest cave in North Carolina is

in the gorge. I have heard individuals speak of cavern rooms as large as football fields. Well, maybe so—or maybe not. Who knows?

The Cherokees apparently kept their specific knowledge of cave locations and contents secret. For them, the caves may have possessed religious significance. And they probably provided places of refuge during times of invasion—maybe even during the removal period of the late 1830s. But there is a set of caves, known locally as the Indian Caves or Rock Houses, which can be clearly viewed across the Nantahala River from U.S. 19. The designation Devil's Kitchen, as applied to these caves, has been, insofar as I can determine, recently coined by someone who wanted a catchy name for the whitewater tourist trade, as per the fancy names applied to various sections of the river in recent decades.

The Indian Caves do not penetrate very far into the mountain slope. There are two roomlike cavities, with the one on the left-hand approach being the largest. It is about fifty feet deep by twenty-five feet wide. The front opening is more than twenty-five feet high, with the "ceiling" at the rear of the room maybe eight to ten feet high. The two rooms are connected by a doorwaylike passage so that one can move easily between them. In addition there are various windowlike openings and alcoves. Early twentieth-century newspaper stories reported "hieroglyphics carved on the walls." There is, to be sure, an aura about the site that would make hieroglyphics appropriate, but none can be located today.

The caves were carved from what appears to be slate, schists and maybe some steatite. When the river was higher many thousands of years ago, it clearly ate into these soft formations, creating the rooms as well as the passageway.

A nongeologic explanation for the origin of the Indian Caves is provided by Cherokee legends, which credit them to the Little People. Those folks were the Cherokee equivalents of Irish leprechauns. According to one authority on the Little People, "their stature ranges from slightly more than one foot to about three feet. They occupy a variety of habitats, including laurel patches, the areas behind waterfalls, and rock slides. They are notorious rock throwers, though their aim is erratic."

But the Little People were mostly benevolent, if mischievous. Their main task was to look after Cherokee children lost in the woods. The Cherokees fell into the habit of blaming anything they couldn't readily explain on the Little People. So they naturally figured that the Little People had dug the Indian Caves. Carl Lambert, Cherokee historian and storyteller, now deceased, assured me back in the 1980s, with a gleam in his eye, that the Little People inhabited the gorge and used the caves.

"The old Cherokees," he said, "would never pass the Indian Caves without leaving some fish they had caught or game they had killed for the Little People. You don't want to make them mad. You want them on your side."

A story about the Indian Caves named "The Dancing Ghosts" was collected from either Will West Long or his half-brother Morgan Calhoun in the late 1920s

by anthropologist Frans Olbrects. In this account, a few hunters went there and built a fire in the smaller room. Later on, a few more hunters came. Pretty soon, they all lay down to sleep. But one of them was raucous, and he began to sing loudly the song called "Adahona" ("The Women's Dance"). In this dance the women wear box turtle leg rattles, which are clusters of four or five dried shells filled with pebbles that have been sewn onto leggings. By skillful movement, the women dancers pound out a vigorous rhythm. The Cherokee artisan Lloyd Owle captured the spirit of those long-ago rhythms in a poem:

Indian Turtle Shells

As Indians dance
The turtle shells rattle
To create a rhythm
A rhythm the Indians dance by.
As the Indians dance
Empty shells begin to rattle
The turtle's life is gone
The turtle rattles of death.
The Indians dance
The turtle shells rattle
Who cares for death?
This is a happy time.

The hunter kept loudly and brazenly singing "Adahona" into the night until suddenly he heard the eerie sound of rattles in the opposite room. The other hunters were awakened. It wasn't a happy time for them. They feared that the woman dancing to the rattling shells in the next room was a ghost dancer. "Let's get away from here!" they all shouted, and then they fled into the night.

The construction of the Western North Carolina Railroad through the Nantahala Gorge during the late 1880s was much delayed at Red Marble Gap in the western end of the gorge because of the steep gradient. Some of the convict labor brought in to construct the appropriately named Hawknest Trestle (now destroyed) as a way of getting out of the gorge was housed in the Indian Caves under armed guard.

Each Sunday morning, Reverend Joseph Wiggans, who lived in nearby Graham County, rode to the caves on his horse and preached a sermon for the convicts' benefit. The convicts always listened attentively; they had, after all, been told stories about Reverend Wiggans's disposition. In one of them that took place shortly after the Civil War, some bushwhackers in the area advised the minister that he would be "ridden on a rail" out of one place if he dared to preach there

again. Not perturbed in the least, Reverend Wiggans arose, placed his six-shooter on the pulpit, and casually remarked by way of preface to his sermon, "I do not ride rails."

Later settlers in the Nantahala Gorge used the caves as shelter for their livestock, or their children used them as readymade hideaways. Today thousands of whitewater enthusiasts and passengers on the excursion railroad that runs from Dillsboro to Murphy either float by or ride by the caves each year. Most are totally oblivious to the fact that a stone's throw away there's an ancient rock shelter that was created millions of years ago by ancient geologic forces where ancient Cherokee lore and more recent Western North Carolina history are intermingled.

Cowee Bald and the Powder Horn Map

Cowee Bald, situated at 5,080 feet on the Macon-Jackson line just south of where those counties corner with Swain, was once a natural grassy area to which white settlers drove livestock for fattening. According to William S. Powell's *North Carolina Gazetteer: A Dictionary of Tar Heel Places* (1968), the name *Cowee* is of Cherokee origin and signifies "place of the Deer Clan."

Now the site of a fire tower and a complex of communications and metrological equipment, the open area offers an excellent spot from which to obtain some of the best views in the region. To the south, one looks out over Franklin into north Georgia. To the east, the view is over Sylva back through Balsam Gap toward Waynesville. To the west toward Tennessee, the high dark line of the Nantahalas is etched against the skyline. And to the north loom the Great Smokies, the most massive mountain range in eastern North America.

The Cowee Range arises just south of the Tuckasegee River at Bryson City and bends southeastward to a point where it abuts with the mountain ranges near Highlands. As such, it divides the two dominant river systems of the region: the Little Tennessee and the Tuckasegee.

Cherokees living at the towns centered around their major settlement of Cowee, on the Little Tennessee, and those at the towns near present-day Whittier, on the Tuckasegee, passed back and forth via a tortuous trail crossing the Cowees near the old bald. Rock shelters and hunting camps at Rattlesnake Mountain and Slipoff Creek have been excavated by archaeologists, who date human use of the sites

back many thousands of years before the Cherokees emerged as a distinct culture about a thousand years ago.

Much has transpired there, but the most dramatic recorded moment in Cowee Bald's history occurred in July 1761. At that time, a British expeditionary force numbering more than twenty-eight hundred soldiers under the command of Lieutenant Colonel James Grant traversed the mountains in the Cowee Bald area, passing from the Cherokee towns at Cowee, which they had burned to the ground, on to the Tuckasegee settlements, which met a similar fate.

Rather astonishingly, the route of the expeditionary force is clearly delineated on a powder horn now on display at the Museum of the Cherokee Indian. Carved in the artistic scrimshaw style perfected by sailors for use on whalebone, the horn was presumably made by one of the participating soldiers. In 1976, it was obtained by George M. Clark of Chattanooga, Tennessee, from Thomas and Vanessa Doyle of Dun Laoghaire, Ireland, and donated to the museum.

An article by Duane King, former director of the Museum of the Cherokee Indian, titled "A Powder Horn Commemorating the Grant Expedition against the Cherokees," was published in the *Journal of Cherokee Studies* in 1976. Therein, King described the incidents leading up to the invasion, the crossing of the Cowees and the powder horn.

It's supposed, but not verified, that a member of the Doyle family (whose ancestors served for many generations in the British Army) made the carving as a personal commemoration. The horn is dated 1762 under this inscription: "A new map of carolina and Likwise a plan of Ye Cherokee Nation Congurd by the arme Commandt by Lieeutt Col Jas Grant." The horn provides the only contemporary map of the invasion route. And it is one of the few maps locating several of the Cherokee settlements.

The 1761 war was the culmination of a series of events initiated several years earlier, at which time a number of Cherokee warriors fighting in Pennsylvania as English allies were murdered by white frontiersmen in Virginia while returning home. Enraged and bound by traditional law to exact blood revenge, relatives of the slain warriors struck at English settlements in North Carolina.

Cherokee leaders who traveled to Charleston, South Carolina, seeking to placate matters were summarily chained and marched to Fort Prince George in American Indian country in upstate South Carolina. An ultimatum went out that they would not be released until the Cherokees responsible for the killings were surrendered for punishment. As tensions evolved into conflict, the commander at Fort Prince George was killed, as were the twenty-two members of the Cherokee delegation confined in the fort. The bounty paid by South Carolina for Cherokee scalps was upped to thirty-five pounds apiece.

An army under the command of Colonel Archibald Montgomery burned towns in the lower American Indian settlements but hastily withdrew to Charleston after sustaining heavy casualties in an ambush. The aroused Cherokees captured Fort

Loudon in present-day East Tennessee and killed twenty-five or so of their white prisoners. South Carolina officials, "determined to bring the Cherokee Nation to its knees," increased the scalp bounty to one hundred pounds and requested British troops. Enter Lieutenant Colonel James Grant, who landed in Charleston with a veteran force of about twelve hundred British regulars in January 1761.

The powder horn depicts the route from there to Fort Ninety-Six, where the force arrived on May 18. Now numbering more than 2,800 soldiers, the expedition included Carolina Provincials, a battalion of Royal Scots, more than 400 rangers, 240 wagoners, a score each of Catawba and Chickasaw scouts and 81 black slaves. Six Mohawk warriors also joined the party, not because they favored either side but "purely for the love of fighting."

Carrying their weapons and "minimal supplies" of "blankets, bearskins, and liquor," the army moved out into American Indian country, trailed by six hundred packhorses. At eight o'clock on the morning of June 10, "the high blue wall of the Cowee Mountains loomed in the foreground" and all hell broke loose. For the next five hours a ferocious running battle ensued along the banks of the Little Tennessee.

After sinking their dead in the river, the British reorganized and commenced burning towns and destroying crops. On the night of June 25, Grant left a contingent of one thousand to guard sick and wounded soldiers at the Cowee Townhouse and set out over the Cowee Mountains with his British regulars to launch a major assault on the Cherokee "Out Towns" located along the Tuckasegee River, which today flows through Sylva and Bryson City before emptying its waters into Lake Fontana. The powder horn clearly delineates their progress up through Leatherman Gap, across the headwaters of Alarka Creek in the Big Laurel region just north of Cowee Bald, through Wesser Gap and on down Connelly Creek to present-day Whittier, a community located alongside the Tuckasegee River just east of Bryson City.

Grant's force of Indian Corps scouts and soldiers had all fought in rough country before; indeed, some among the British had fought in the Alps and other rough terrain. But the mountainous terrain here in Western North Carolina also gained their respect. Captain Christopher French recorded in his diary: "The mountain which is upwards of two miles to the top and extremely steep which made a fatigue beyond description to get up it [was] the strongest country I ever saw, anything we had yet passed being nothing in comparison to it. [The] mountain…was so very steep and made slippery by some rain…that it was nearly as difficult to get down as up." Grant reported to his superiors that the crossing represented "perhaps [the] steepest in America."

Along the Tuckasegee they encountered little opposition, as the Cherokees had fled to the hills, but they destroyed the towns of Stickoee (Whittier), Kithuwa (the ancient mother town at Governor's Island), Tuckaleechee (Bryson City) and Tesuntee (unknown). A letter written by Lieutenant Francis Marion, who

subsequently became renowned as the "Swamp Fox" during the American Revolution, described the episode as follows: "We proceeded, by Col. Grant's orders, to burn the Indian cabins. Some of the men seemed to enjoy this cruel work, laughing heartily at the curling flames, but to me it appeared a shocking sight. But when we came, according to orders, to cut down the fields of corn, I could scarcely refrain from tears. Who, without grief, could see…the staff of life sink under our swords with all their precious load, to wither and rot untasted in their mourning fields?" As a farewell message, Grant's Mohawk warriors rammed a stick down the throat of one of the captured Cherokees, stuck arrows through his neck and cleaved his head before returning to Cowee.

Sick, exhausted and victorious, but no longer in a fighting mood, Grant's army withdrew from American Indian country after thirty-three days of sustained battle, having made their point with a scorched-earth policy that demoralized the Cherokees. A relative peace ensued that lasted until the outbreak of the American Revolution in 1776, when the Cherokees, still remembering the part played by Carolinians in the 1761 invasion, launched savage attacks against the Colonial frontier.

The Cowee Bald area is easily traversed these days via U.S. Forest Service roads. In 1761, however, Grant's hardened British regulars found the crossing— so meticulously depicted by some talented and unnamed survivor on his powder horn—to be one of the most memorable yet attempted in North America. A subsequent high-elevation crossing by Confederate troops of the Great Smokies during the Civil War was, perhaps, more arduous. Even so, the 1761 crossing certainly ranks as one of the more dramatic military maneuvers in Western North Carolina's history.

Big Bear's Reserve:
From Indian Village to
Mountain Town

The story of the land transactions and disputes that led to the establishment of Bryson City is informative in that it typifies in many ways the transmission of lands from Cherokee holdings to white settler villages and towns that took place throughout Western North Carolina during the nineteenth century.

This small town at the mouth of Deep Creek on the Tuckasegee River just east of Lake Fontana in Swain County on the North Carolina boundary of the Great Smoky Mountains National Park was a village named Charleston before it became Bryson City in 1889. Before that it was a tract of land known as Big Bear's Reserve, which was itself located in the same general area as the old Cherokee village of Tuckaleechee, which had been ravaged by Lieutenant Colonel James Grant's British expeditionary force in 1761.

Big Bear (Yanegwa or Yonah) was a Cherokee chief who lived in the area where Bryson Branch empties into the Tuckasegee River from the north. The historical account by anthropologist James Mooney in his *Myths of the Cherokee* (1900) indicated that Big Bear was the leader of the Cherokees in this part of present-day Western North Carolina, being succeeded in that role by Yonaguska (Drowning Bear) and then by his adopted white son, Will Thomas.

It's reputed that Big Bear is buried underneath one of the large boulders on the old home site of Colonel Thaddeus Bryson, for whom the town was later named. There are supposed to be pictographs—American Indian heads and the like—carved on some of the rocks in the area, if you know just where and how to look. I've tried, but apparently didn't know either where or how.

The past dies slowly here in the little mountain communities; memories of the past linger longer than in the larger towns and cities. Old-timers here in Bryson City still

recalled during the 1970s, when I was locating these sites, that "Big Bear's spring" was located at the foot of the road leading over Coal Chute Hill to the old Singer Plant; that "Big Bear's ford" was used into modern times, being located on the west side of the lower town bridge; and that "Big Bear's canoe landing" was in the immediate area.

According to Mooney, "Big Bear was among the signers of the treaties of 1798 and 1805, and by the treaty of 1819 was confirmed a reservation of 640-acres as one of those living within the ceded territory who were 'believed to be persons of industry and capable of managing their property with discretion,' and who had made considerable improvements on the tracts reserved." The mile-square tract apparently included most of the flatland on both sides of the Tuckasegee River west of the mouth of Deep Creek; that is, the central portion of present-day Bryson City.

Big Bear was ceded his reserve in early 1819. Later that same year, he signed a deed for the land, giving it over to a white man named Darling Beck. That's when the trouble started. In a 1959 *Asheville Citizen-Times* article titled "Indian Twice Sold Land That Is Now Bryson City," Karl Fleming reported that:

> *History has it that Beck, who evidently was no darling, plied Big Bear with giggle-water and got his signature on a deed which exchanged the land for a promise of $50. Big Bear claimed he never got the money and about a year later, on November 25, 1820, he deeded his 640-acres of land to John B. Love in return for a wagon and a team of horses...Love immediately took possession of the land and Beck responded by filing in the courts a suit of ejectment. The court ruled that Beck was legal owner of the land and Love appealed to the State Supreme Court, which upheld the lower court decision in its December sitting in the year 1834. Not satisfied with this, Love filed suit on October 13, 1835, against the widow of Beck, who had, in the meantime expired....Love's suit was a suit in equity whereas Beck's suit had been an action at law in ejectment. The distinction between actions at law and suits in equity was not abolished in North Carolina until the state adopted its present constitution in 1868. Love attempted to show that Beck and Big Bear had rescinded their trade and that he was the rightful owner of the mile square. The court ruled that Love was entitled to the property as his was the superior title. In 1841, Love, who, it will be remembered, came into possession of the land for a wagon and a brace of mules, turned a tidy profit by selling the tract to John Shuler for $2,500.*

In turn, portions of this land were owned by members of the Burns, Bryson and Cline families before being deeded to form Charleston, the county seat of Swain County, in 1871. The village of Charleston was not incorporated until 1887, two years before the name was changed to Bryson City, in order to avoid confusion regarding mail that was mistakenly being sent to the larger city in South Carolina.

Tuckaleechee, Big Bear's Reserve, Charleston, Bryson City—all the same place. And for the most part it's been a pretty quiet place. Probably the only truly momentous event to ever transpire here took place more than a century and a half ago. That was in 1838, when, according to a letter written by Will Thomas on November 25 of that year, the Cherokee martyr Tsali "was brought in yesterday by some of the Indians lying out on the Nantihala [and] by them tried and shot near Big Bears reserve on Tuckasega."

Tsali, Tsali's Rock and the Origins of the Eastern Band

The story behind the removal of the major portion of the Cherokee people to Oklahoma in 1838 is generally well known. The origins of the Eastern Band of Cherokees—those still residing in Western North Carolina—is, however, not widely understood. That story was initiated long before the removal actually took place via treaties signed in 1817 and 1819.

U.S. military forces removed approximately sixteen thousand Cherokees during 1838 over various land and river routes. Many encountered unusually severe winter weather. The weather and the fact that they were not properly clothed or provisioned resulted in the death of approximately four thousand Cherokee refugees. *The Trail of Tears*, as the event came to be known, is not a misnomer.

After the military departed and the dust had settled, approximately eleven hundred Cherokees remained in Western North Carolina. About half of these had avoided removal by hiding out from the military in the high mountains. The others, sometimes referred to as the Citizen Cherokees, were exempted from removal because of the earlier treaty provisions. It's the Citizen Cherokees' part in the story that's not widely understood. And there are portions of that story involving the Cherokee martyr Tsali that have also been obscured.

In his introduction to *Cherokee Removal: Before and After* (1991), editor William L. Anderson noted that the Treaty of 1817 contained the first provision for removal, with approximately 1,750 Cherokees deciding to go west at that early date. And the treaty also contained a proposal for "an experiment in citizenship. Cherokees who

wished to remain on ceded land in the east could apply for a 640-acre reserve and citizenship." The Treaty of 1819 also contained clauses providing for Cherokee citizenship. Fifty-one Cherokee families opted for the 640-acre reserves and citizenship opportunities, even though in doing so they in essence gave up their tribal identities. For those reasons, the present-day Eastern Band of Cherokees trace their origins back to those two related treaties.

In an essay titled "The Impact of Removal on the North Carolina Cherokees," contributed to the volume cited earlier, John R. Finger observed that even though "they claimed to be citizens of North Carolina...their precise status was in fact uncertain. Unfortunately, whites had already intruded on many of these private reservations, and during the 1820s North Carolina negotiated cash settlements with most of the Indian reservees. Some moved back to the Cherokee Nation [in Oklahoma] while others clustered around a site known as Quallatown, near where Soco Creek joins the Oconaluftee River [in present-day Cherokee]. Their chief was an imposing individual named Yonaguska (Drowning Bear), who in turn relied on a local white merchant, William Holland Thomas."

As a boy, Will Thomas had been adopted by Yonaguska, thereby becoming a de facto member of the tribe and, in time, "their trusted adviser." When the removal movement became an alarming concern in the mid- to late 1830s, it was Thomas who spearheaded legal battles that allowed the Quallatown Cherokees and others to be at least nominally recognized as citizens of North Carolina so as to prevent their removal west.

Finger noted that "In carrying out his major purpose...Thomas argued forcefully [in Washington in 1836] that his clients should be allowed to remain in North Carolina—the Quallatown Indians because they were already supposed citizens, and the others because they were qualified to become citizens under Article 12 [of legislation passed in 1835]." And it was Thomas who time and again reminded the military leaders taking part in the removal process in Western North Carolina in 1838 that the Quallatown Indians were North Carolina citizens and thereby exempt from being removed. Things were going along pretty well in that regard until the fall of 1838. That's when the Tsali incident erupted.

There are various versions of the Tsali story. Here's the account I've pieced together based upon what various historians like Anderson and Finger have written as well as upon an analysis of the pertinent military and other contemporary records selected by Duane King and published in 1979 as a special issue of the *Journal of Cherokee Studies*.

Tsali, a sixty-year-old farmer, unwittingly became a prominent figure in Cherokee history and lore. On October 30, 1838, a detachment of soldiers led by Second Lieutenant A. J. Smith and accompanied by Will Thomas captured twelve members of the Tsali family somewhere along the Tuckasegee River, probably about halfway between present-day Bryson City and where that river then flowed

into the Little Tennessee. Smith, who was apparently inclined to be a volatile individual, was fatigued after a long trip to South Carolina to capture fifteen Cherokee fugitives. Upon encountering the Tsali group by chance, he divided his command, sending the fifteen original fugitives on down the Little Tennessee toward Fort Cass, just over the state line in Tennessee. Smith, with three of his men and Thomas, remained behind to round up as many members of the Tsali group as they could.

Upon arrival at James Welch's house at the confluence of the Little Tennessee and Tuckasegee rivers (where Camp Scott, a military installation, was also located on lands presently inundated by Lake Fontana), Smith learned that the Cherokees captured in South Carolina had escaped. He began pushing the Tsali group "with all possible speed" down the river. Somewhat inexplicably, because of an unspecified "accident," Will Thomas remained behind.

In the Fairfax area, located near the present Lake Fontana dam, Tsali's family revolted on the evening of November 1, killing two soldiers and injuring another. There are various versions of the specific events that led to the killings; nevertheless, one can safely assume that resistance to being captured and forcibly removed from one's homeland was the precipitating factor. Smith escaped the fracas on horseback and rejoined Thomas, who accompanied him to Fort Cass.

For Thomas, the incident was a monkey wrench tossed at the last minute into his careful plans aimed at allowing the Quallatown Indians and other Cherokees to remain in Western North Carolina. For the U.S. military, it was a bloody mess, an incident that couldn't be ignored without retribution.

General Winfield Scott ordered Colonel William S. Foster and nine companies of the Fourth Infantry into Western North Carolina, stipulating that "The individuals guilty of this unprovoked outrage must be shot down." Thomas, as an expert on the Cherokees and the terrain, joined the punitive expedition. He no doubt wanted to be on hand to orchestrate events as much as possible.

Accounts of what happened and where are again varied, but contemporary military records, as well as correspondence between Thomas and other principals in the affair, document the fact that Tsali and his family were hunted down by Euchella, Wachacha and members of their respective Cherokee bands. They apparently did so in exchange for being allowed to remain in Western North Carolina. Tsali family members Jake, George and Lowan were captured and then executed on November 23. Tsali himself was captured on November 24, quite likely at a rock shelter in the present-day Great Smoky Mountains National Park. The following day he was executed by Euchella and Wachacha "near Big Bear's Reserve," a military camp situated on the site of a 640-acre allotment made to Big Bear and his family in 1817 and the site of present-day Bryson City.

The mythologizing and polishing of the Tsali legend, in which Tsali willingly gave himself up to be executed so that his people might remain in their Western North

Carolina homeland, began as the incident itself was unfolding and has continued to this day. What is clear is that, while Tsali didn't willingly surrender or make a grand speech when he did so, his death removed the final stumbling block faced by the Quallatown Indians and others in their decades-long effort to resist removal.

One of the colorful staples of Western North Carolina lore has been Will Thomas's account of going to a "cave" on the Left Fork of Deep Creek above present-day Bryson City in the high Smokies, where he talked to "Old Charley" (as Tsali was known to whites) and persuaded him to give himself up in order to save his people. In some accounts, Tsali's noble speech upon surrendering has been reported as if recorded verbatim by a court stenographer. It's unlikely that Thomas was even present when Tsali was captured, although he probably observed the various executions.

Yet, even if the facts of the incident don't correspond with the myth, Tsali still rightfully takes his place in Cherokee history and lore as a man who resisted removal. And his name rightfully endures as a symbol representing all those who lost their lives on the Trail of Tears. As such, the place where he last hid out in the Smokies is of considerable importance to the Cherokees and others with an interest in their history.

A persistent oral legend in the Bryson City area maintains that a site known as Tsali's Rock or Tsali's Cave or the Charley Rock, in what is now the Great Smoky Mountains National Park, marks the spot where he was forcibly captured. The rock is located about ten miles north of the Deep Creek Ranger Station, several miles up the Left Fork of Deep Creek, and maybe three miles east of Clingmans Dome, near the mouth of Keg Drive Branch. That's some of the roughest territory in the Smokies. Just getting in and out of the Left Fork watershed can be grueling even in good weather conditions. Making your way through the rhododendron tangles along the creek is exasperating. Locating the precise site is almost impossible without a guide who has been there before and knows exactly where to look.

In the late 1940s, Deep Creek resident Ben Lollis, now deceased, took Bill Rolen, also now deceased, but then a park ranger stationed in the Bryson City area, to the rock overhang. (There's no cave.) Rolen showed me photographs of the site and told me that Lollis said, "All the old-time hunters, loggers and farmers call it the Charley Rock because they were told by their ancestors that that's where Tsali last hid out."

Gilliam Jackson, a full-blooded Cherokee raised in the Snowbird Community near Robbinsville in Graham County, along with this writer and my wife, Elizabeth, used the directions and photographs provided by Rolen to locate the site in 1984. We made four attempts before finally finding it. Curiously enough, Jackson had previously tried to locate the site using Cherokee oral tradition passed down in his own family and had come within several miles of it. One will never be able to prove beyond a shadow of a doubt that this is the certified site where Tsali was

captured, but the fact that the oral traditions in both the Cherokee and white cultures coincide adds credence to the notion. Coincidentally, perhaps, a military rifle passed down from old-time Deep Creek families was reputedly used in Tsali's execution. It is now on display at the Museum of the Cherokee Indian.

The rock shelter is well situated, being a shelving rock high on a wooded slope above a dense rhododendron thicket along the main Left Fork. A small springhead several yards away from the shelter provides a constant supply of freshwater. As the rock now stands (there are indications it may have slipped some in recent years, thereby limiting the space under the overhang), three or four adults could find adequate shelter there. It's the only outcrop of any size in that area and was probably used as a hunting camp by the ancient Cherokees long before Tsali supposedly sought refuge there in 1838.

Insofar as anyone is aware, Jackson was the first Cherokee to visit the site since Tsali was captured there. He later went back on his own and spent the night. A terrific thunderstorm that lasted for hours, creating an ongoing firestorm of lightening bolts all around the site, persuaded Jackson that it is perhaps "not a good place" for Cherokees.

So, in the spring of 1839, after the forced removal and military departure, there were approximately eleven hundred Cherokees left behind in Western North Carolina. These represented fugitive individuals who had come down from their mountain hideaways as well as the Quallatown Indians and other Citizen Cherokees. As the remnant Eastern Band of Cherokees in Western North Carolina, they now number about twelve thousand on their official rolls.

In the early 1990s the Cherokee Tribal Council designated November 25 as an official holiday honoring Tsali. A proclamation was composed and read by a Cherokee grade school class. It concluded as follows: "On November 25, 1838, Tsali was executed by Euchella and Wachacha. They used to be his neighbors. They were ordered to kill him so they could stay in North Carolina. Tsali was killed. We are still here. Tsali is a Cherokee hero."

Swimmer, Mooney and the Cherokee Sacred Formulas

One of the significant moments in Western North Carolina and Cherokee cultural history took place in 1887. During the summer of that year, anthropologist James Mooney met the Cherokee medicine man named Swimmer. Had Mooney not had access to Swimmer, his writings about Cherokee life and lore, which culminated in *Sacred Formulas of the Cherokees* (1891) and *Myths of the Cherokee* (1900), would have not, in many ways, become the monumental studies we know today.

One of the most intriguing—and neglected—portions of Mooney's work is that devoted to the sacred formulas. These chants, incantations, prayers, songs, prescriptions and exhortations provide direct access to the inner core of the Cherokee belief system and psyche.

Mooney was a young employee working at the Bureau of American Ethnology in Washington, D.C., when he met Nimrod Jarrett Smith, the Eastern Band's principal chief, in the mid-1880s. Even though Mooney had never conducted fieldwork, Smith saw something in the young Irishman and invited him to visit his people in Western North Carolina.

Mooney was twenty-six years old when he disembarked at the rail and telegraph station at Whittier in 1887. Upon Mooney's arrival at the Qualla Boundary (Cherokee), Chief Smith took the budding anthropologist under his wing, inviting him to observe the Green Corn Dance and other ceremonies. He also introduced him to his son-in-law, James Blythe, a graduate of the Quaker college in Maryville, Tennessee, who later became the first American Indian to serve as a federal agent

among the Eastern Band. Blythe served as Mooney's interpreter for a period and then introduced him to another interpreter, Will West Long, who was to become the foremost Cherokee medicine man of the twentieth century.

In that manner, Mooney was first exposed to Swimmer. Long was then working with the great shaman, absorbing from him the ancient stories, myths, sacred formulas and medicinal plant lore. Swimmer was more than fifty years old at the time. Although Mooney had numerous informants among the Eastern Band and even among the Cherokee Nation in eastern Oklahoma, Swimmer was his most important by far. Mooney later credited "nearly three-fourths" of the material he collected to him.

In *Sacred Formulas*, Mooney recorded that one day in the late 1880s Swimmer "produced a book from under his ragged coat…and said: 'Look at that and see if I don't know something.'" To the young anthropologist's utter astonishment, "It was a small day-book of about 240 pages…about half-filled with writing in the Cherokee characters… Here were prayers, songs, and prescriptions for the cures of all kinds of diseases—for chills, rheumatism, frostbites, wounds, bad dreams, and witchery; love charms…fishing charms, hunting charms…prayers to make the corn grow, to frighten away storms, and to drive off witches; prayers for long life, for safety among strangers, for acquiring influence in council and success in ball play. There were prayers to the Long Man, the Ancient White, the Great Whirlwind, the Yellow Rattlesnake, and to a hundred other gods of the Cherokee pantheon. It was in fact an Indian ritual and pharmacopoeia."

Using the syllabary invented by Sequoyah earlier in the century, Swimmer and other medicine men had been recording their precious knowledge. Recording, studying and translating these formulas became an important part of Mooney's work. And subsequent students of Cherokee lore have followed his lead in regard to materials produced by both the Eastern Band and the Cherokees living in Oklahoma. Exceptionally productive work in this regard has been produced by Jack and Anna Kilpatrick and their son, Jack, themselves of western Cherokee descent.

For some years now, I have been making my own renderings from English translations of the sacred formulas. These renderings are conflations of various thematic materials that crop out in the body of the sacred formulas. Here's an example:

Examine the Stones

Listen!
You the spirit who resides everywhere
Who foresees and overlooks nothing
Who knows all and provides and keeps no secrets
Who remakes the silent stones to speak again.
As astonishing as it might seem
I have come to question you.

Now!
You have stated that you tell the truth,
that you deliver the truth in all places.
I have come to petition you.
Quickly let me know.
Examine the stones.
Tell me the way it is.

Stone! Grandfather! Father!
Speak to me…raise me up.
Tell me what I am thinking about.
I have come to yearn for the truth.
I want to know where I am going.
The pathway always divides.
Remake it the right way.

Geronimo and the Eastern Band

Dating back to the time of Hernando de Soto's sudden and vicious arrival in Western North Carolina in 1540, numerous incredible episodes dot the region's historical landscape. One such event occurred when the federal government came very close to moving the warrior Geronimo and other captive members of his renegade Apache band from a prison in Alabama onto lands occupied by the Eastern Band of Cherokees in Western North Carolina.

A limited portion of that story is told in an article by Walter L. Williams titled "The Merger of Apaches with Eastern Cherokees: Qualla in 1893," published in 1977 in the *Journal of Cherokee Studies*. A fuller picture, as related here, unfolds in editorials, articles and letters to the editor that appeared in the *Swain County Herald*—that county's first newspaper—from mid-1889 through late 1890. Most of the present-day lands of the Eastern Band in Western North Carolina are situated in the eastern portion of Swain County, adjacent to the North Carolina boundary of the Great Smoky Mountains National Park, which wasn't founded until 1934.

In 1889, Geronimo's band was being held at the Mount Vernon Barracks, about forty miles north of Mobile, Alabama. Members of the Chiricahua tribe, they numbered 75 men and about 250 women and children.

Geronimo, then sixty years old, was a tribal leader but not a chief. As a young man, he had exhibited courage and skill in successive raids of vengeance upon Mexicans, who had killed his mother, wife and children in 1858. After the Civil War, an effort was made to limit the territory of the Apaches. Savage retaliatory raids

by the American Indians brought action by the U.S. Army under the command of General George Cook. Apaches implicated in the raids were impounded on reservations, but Geronimo's band fled to Mexico. From 1876 until 1886, he led raids against settlers in the United States, gaining recognition as "the most cunning" of all the American Indian warriors faced by the American military. During the final eighteen months of this campaign, the U.S. Army employed 5,000 troops and 500 American Indian auxiliaries. Operating in two countries with bases of supply, the Apache opposition was composed of 35 men, 8 boys and 101 women.

When the Chiricahuas finally surrendered in 1886, they were promised reunion with their families on "a large, well-stocked reservation." Instead, they, along with seventeen American Indian scouts who had assisted the U.S. Army in their capture, were shipped in boxcars to Florida and incarcerated—the men at Fort Pickens, the women at Fort Marion.

In April 1887, President Grover Cleveland, responding to reports that malaria was rampant among the Apache prisoners, agreed to have them moved to the Mount Vernon Barracks. Captain John G. Bourke of the Third Calvary and James C. Painter, a Congregationalist minister from Boston active in the Indian Rights Association, were appointed by the War Department to look after Apache interests. The American Indians requested that they "be allowed a fresh start somewhere near a river and in a place where it snowed [and] where they could see long distances."

After a tour of the south, Bourke and Painter determined that Eastern Band of Cherokee lands in Western North Carolina best suited Apache needs. Western North Carolina residents learned of this plan in July 1889 when the *Swain County Herald* reprinted an article from a newspaper in Charleston, South Carolina. This article reported that a tract of about ten thousand acres had been located "in Swain County, N.C., which is at present occupied by about 2,000 Cherokees. The Cherokees are willing to sell [and] Geronimo is delighted with the prospect of removal, but is disappointed at not getting back to Arizona."

Herald editor H. A. Hodge stated that he had questioned Eastern Band agent James Blythe, who confirmed that lands in Big Cove or along the Oconaluftee or in the Cowee Mountains between Bryson City and Whittier (the so-called 3,200-Acre Tract, which is today still a part of Eastern Band lands) "might be sold." In his next editorial, Hodge concluded that there "seems to be a pretty good foundation for the talk, but what do the citizens of Swain County say? We have as yet no expression from them."

Even in the remote mountains of Western North Carolina, Geronimo was not an obscure name. One response headed "Geronimo Again!" and signed "Victim" noted that "Geronimo almost drank my blood" and that in New Mexico "a monument of stones marks the place where my comrades lie buried." His concluding sentiments indicated the fervor the matter was arousing locally: "Incumber not, I say, the fertile valley of the Tuckasegee with Geronimo and his

band of outlaws, but as military prisoners give them their dues while they live and when they are removed give them all that has been left their victims, a fit resting place for their souls and six feet of earth for their bodies, but not even that in quiet old North Carolina."

On September 5, 1889, Superintendent H. W. Spray of the Eastern Cherokee Training School wrote the *Herald* on behalf of the Apaches. Spray argued that they should be allowed to come because they were "asking to walk in the white man's path." He also pointed out that while the possibility of the Apaches occupying white citizens' places "is remote in the extreme...their rights of occupation are much older."

Many citizens agreed with Spray. A poll made by Hodge of sixty-nine "citizens of prominence" (no women, no Cherokees) tallied thirty-seven for bringing the Apaches to Western North Carolina, twenty-five against, and seven neutral. Captain A. F. Rice, one of the men polled, was somewhat philosophical: "I look at this question from Geronimo's point of view, and if his band can stand it I guess we can."

But the opposition, led by Hodge, who editorialized that "Swain County don't want them," prevailed during the following year. Influential politicians on the regional, state and federal level were enlisted to keep the Western North Carolina removal from taking place.

Hodge resigned his post and sold the newspaper in late 1890. The last extant issue for the paper is dated December 1890.

Meanwhile, the Apaches languished in Alabama. Their old adversary General Cook was sent to Western North Carolina to survey the situation. He wasn't opposed to a possible move here but felt a drier climate would be best. In December 1893, Captain W. W. Wotherspoon (commander of the Mount Vernon Barracks) journeyed to Swain County and decided there was not enough suitable land to warrant bringing the Apaches onto the reservation. In September 1894, the War Department ordered their removal from Alabama to Fort Sill, Oklahoma.

"The last part of the trip was across open country," wrote Donald Worcester, in his excellent account titled *The Apaches: Eagles of the Southwest* (1979). "When the Apaches first heard coyotes howling in the distance the women began to wail, for they had not heard that sound for 8 years."

By orders of President Cleveland that ran counter to the terms agreed upon by the Apaches, Geronimo and fourteen other male members of the Chiricahua band were placed under military confinement. But until his death in 1909, Geronimo was allowed to farm and raise stock.

In 1913, the remnant Chiricahuas were asked to choose between remaining in Oklahoma or moving west. Most chose to go west. Today, except for those residing near Apache, Oklahoma, they live on the Mescalero reservation in southern New Mexico. Geronimo and his band never quite made it to Western North Carolina, but they came within a whipstitch of doing so.

MOUNTAINEERS

A Peculiar Duel:
Vance versus Carson (1827)

Let's suppose that you intentionally or unintentionally insult someone; after all, that is something that happens from time to time. You deal with it by apologizing or refusing to apologize. There may be words. The possibility of a little fisticuffs isn't beyond the realm of possibility; if push comes to shove…well, that happens…somebody gets a bloody nose or black eye…no big deal.

But let's suppose that early one morning you receive an e-mail captioned "Satisfaction Requested." You open the e-mail and read:

> *Sir, when a man's feelings & character are injured he ought to seek a speedy redress. My character you have injured. I therefore call upon you as a gentleman to give me satisfaction for the same. Be kind enough and man enough to meet me at the Clingmans Dome parking area in the Great Smokies park at 6:30 this coming Friday evening. I shall bring a small-bore pistol and anticipate that you will do the same. Kindly bring the surgeon of your choice. The distance will be as per usual set at ten paces and the firing will commence upon the command of your surgeon. I further call upon you to give me an answer forthwith without equivocation of your sincere intention to honor this request.*

Jeepers creepers, you've just been invited to participate in a duel! In reality, that's not likely to happen in America in the twenty-first century. But up until the mid-nineteenth century, duels were rather commonplace. If you didn't rise to the challenge

during that day and time, your honor in the community was forever tarnished.

By 1804, dueling had become an American fixture. In a typical duel, each party acted through a "second." A second's duty, above all, was to try to reconcile the parties without violence. An offended party sent a challenge through his second. If the recipient apologized, the matter usually ended. If he elected to fight, the recipient chose the weapons and the time and place of the encounter. Up until combat began, apologies could be given and the duel stopped. After combat began, it could be stopped at any point after honor had been satisfied.

Most duelists chose guns as their weapons. The large caliber, smoothbore flintlock pistols Alexander Hamilton and Aaron Burr used in their famous encounter typified American dueling weapons. Many American men owned a pair of such pistols, and, from about 1750 to 1850, many were called to use them.

For every man who gloried in dueling, there were, of course, more who feared it. A word or two passed in private company on a Friday night could well mean a challenge on Saturday morning and death on Sunday. But avoiding a challenge wasn't easy, particularly in the South, where men who refused to duel would be "posted"; that is, a statement accusing them of cowardice would be hung in public areas or published in a newspaper or pamphlet.

John Preston Arthur in his *Western North Carolina: A History* (1914) noted in a section headed "The Law of Dueling" that

> *from the beginning of the nineteenth century the practice of dueling had been common throughout America, the North, even, not being exempt, as witness the fatal encounter between Aaron Burr and Alexander Hamilton. North Carolina had, in 1802, made it a crime to send a challenge or fight a duel or to aid or abet in doing either; but, according to the strict letter of the law, it would be no crime to send a challenge from without the State or to fight a duel on the soil of another State, and in all the duels fought in this section great care was taken to go across the State line into either South Carolina or Tennessee.*

Of the various duels described by Arthur that involved Western North Carolina residents, the most intriguing, by far, was between Dr. Robert B. Vance of Buncombe County and Samuel P. Carson. Carson, a state representative, lived in Pleasant Gardens, a community in present-day McDowell County. Vance "was encouraged by his friends, and especially by young Samuel P. Carson, then in the state legislature, to oppose Felix Walker, whose popularity then was in the descending node, for Congress, but declined to do so till 1823, when he ran for Congress and was elected by a majority of one vote."

The friends became rivals in 1825 when Carson and Vance "were opposing candidates for Congress, and Carson was elected; but in 1827 Dr. Vance invited some of his friends to meet at Asheville, and announced that he would oppose Carson's re-election."

In regard to a political issue involving both men, Vance made reference to Carson's "'benevolent hand'" having been put "'into some other man's pocket than his own.'" Carson answered that "'until Vance should withdraw the charge that he had put his hand into another's pocket to save his own,'" they could be friends no longer, and proceeded to charge Vance with inconsistency.

Thereupon Vance charged Carson with being a demagogue, and when Carson replied that but for Vance' diminutive size he would hold him to account for his "'vile utterances,'" Vance retorted, "'You are a coward and fear to do it.'" Carson's failure to challenge Vance, after having been publicly called a coward, confirmed Vance in his belief that he would not ever do so.

Vance then attacked "the character of Carson's father on a floating tradition that, after the defeat of our army at Camden, Carson, with many other hitherto patriotic citizens of North Carolina, had applied to Cornwallis, while near Charlotte, to protect their property."

After more name-calling by both men, "the challenge was delivered and accepted. It was agreed that three weeks should elapse before the duel, which was to be fought at Saluda Gap, on the line between North and South Carolina, on the Greenville turnpike." Davy Crockett was reputed to have been present as a friend of Carson's.

> *The distance was set at ten paces…and at the word "Fire," Carson sent a ball entirely through Vance's body, entering one and a half inches above the point of the hip and lodging in the skin on the opposite side. It does not appear that Vance fired at all. Vance died the next day, thirty-two hours after having received his wound, at a hotel on the road…When he saw that Vance had been wounded Carson expressed a wish to speak to him, but was led away; and before his death Vance expressed regret that Carson had not been permitted to speak with him, and stated that he had "not the first unkind feeling for him." Vance also told Gen. Burgin that he had fallen where he had always wished to die "on the field of honor."*

Now we get to the strange part of this supposed "dueling" tale. One of Arthur's informants, the reputable historian Silas McDowell of Macon County, advised him that prior to the duel Vance had said: "'I wish he would fight and kill me. Do you wish to know why? I will tell you: My life has no future prospect. All before me is deep, dark gloom, my way to Congress being closed forever, and to fall back upon my profession or former resources of enjoyment makes me shudder to think of. Understand me, McDowell, I have no wish to kill or injure Carson; but I do wish for him to kill me, as, perhaps, it would save me from self-slaughter.'"

It would appear that the most significant duel in Western North Carolina's history was, in actuality, most peculiar; indeed, it was seemingly a successful suicide rather elaborately staged as a duel by one of the participants. This assumption is bolstered by the fact that Vance executed his will shortly before the "duel."

As to Carson, who had been duped into thinking he was in a real duel, he moved to Texas—where he rose in the political world—and never again returned to Western North Carolina. According to Arthur, "The result of this duel is said to have embittered his life."

Cages, Dungeons and Jailhouses

"The courthouse is less old than the town, which began somewhere under the turn of the century as a Chickasaw Agency trading post and so continued for almost thirty years...until that day thirty years later when, because of a jailbreak compounded by an ancient monster padlock transported a thousand miles by horseback from Carolina, the box was removed to a small new lean-to room like a work- or tool-shed built two days ago against one outside wall of the morticed-log mud-chinked shake-down jail; and thus was born the Yoknapatawpha County courthouse."

William Faulkner, *Requiem for a Nun* (1950)

That's Faulkner's contorted rendering of how, during the eighteenth century, the county jail in his mythical Yoknapatawpha County, Mississippi, had been constructed before the courthouse. Faulkner knew a lot about those sorts of things. He thought about them and they worked their way into his renderings of the brooding cultural heritage of the Old South. He understood that jailhouses were as important as courthouses and sometimes even preceded them in existence.

When was the last time you visited your local jail? Hopefully, it wasn't a forced or overextended visit. If not, you probably haven't checked it out lately, unless you're a local journalist or involved with the court system in some manner.

It used to be, however, well over a century ago, that folks paid a lot of attention to jails. They visited them, and communities throughout Western North Carolina took some pride in the uniqueness of their particular facilities. Travelers passing

through inspected jails as part of their agenda. Scribbling journalists described them in some detail for readers, mostly Yankees, interested in the quaint devices to be found in the southern mountains, where outlandish things were supposed to occur with regularity. And sometimes, of course, they did.

Several years ago I purchased the September 1880 issue of *Harper's New Monthly Magazine* (published by Harper and Brothers in New York City) for four dollars from an antiquarian bookseller. I wanted that particular issue because I knew it contained Part III of Rebecca Harding Davis's series titled "By-Paths in the Mountains." Like all the travel writers who toured Western North Carolina in the latter days of the nineteenth century, Davis described the scenic wonders (especially the waterfalls and high vistas), thrilling sports (especially trout fishing and bear hunting), the Cherokees (the "aborigines" of the region), the white settlers (almost always in their "picturesque" cabins) and the "municipal improvements," such as they were. In this latter regard, jails were always a priority. If an author didn't write a bang-up description of at least one of the local jails, the sponsoring publication's editor would have to be reckoned with upon the writer's return home.

After the obligatory visit to Cherokee, where she found "the Nation hidden in the thickets among the ravines of the Soco and Ownolufta [Oconaluftee] hills [where they] were said to have ten thousand acres under cultivation," Ms. Davis proceeded to Waynesville in Haywood County.

The tour of the county jail, "which stood in a field overgrown with goldenrod," was conducted by the jailer:

> *"Only one prisoner there now," he said. "We've had as many as three there for murder at once. Sent from other counties. Our jail's about the only one that'll hold in the mountains." He pushed open the door, and led the way up a flight of stairs, and thrust up a huge iron trap-door…The cage, which forms a part of every Carolina jail, was a square room of stout iron bars, built in the centre of a larger one. It was much better ventilated and lighted than an ordinary cell. The prisoner was chained to the floor, not so closely, however, but that he could stand erect.*

Another jailhouse description from the early 1880s is provided by Wilbur G. Zeigler and Ben S. Grosscup in their wonderfully titled *Heart of the Alleghanies or Western North Carolina: Comprising Its Topography, History, Resources, People, Narratives, Incidents, and Pictures of Travel, Adventures in Hunting and Fishing, and Legends of Its Wilderness*, published in 1883. Note that until about 1900 the mountains of Western North Carolina and adjacent states were often referred to as the All*a*ghenies. (The preferred spelling today is with an *e* after the *l*.) As of now, the All*e*ghenies are usually thought to be in a mountain range in Pennsylvania, West Virginia, Maryland and Virginia.

Before making their own obligatory visit to Cherokee, Zeigler and Grosscup visited Charleston (present-day Bryson City), "a pleasant little village…situated by

the Tuckasegee river at the foot of Rich mountain," so as to take a look at the jail, which they described in some detail:

> *The old, frame court-house has its upper story used as a grand jury room, and its lower floor…holds the jail. The dark interior of the "cage," used for petty misdoers, can be seen under the front outside stairs, through a door with barred window. An apartment fitted up for the jailer is on the same floor, and, by a spiked, open slit, about six inches by two feet in dimensions, is connected with the "dungeon." For its peculiar purposes this dungeon is built on a most approved pattern. It is a log room within a log room, the space between the log walls filled up with rocks. It is wholly inside the frame building. Besides the opening where the jailer may occasionally peek in, is another one, similar to that described, where a few pale rays of daylight or moonlight, as the case may be, can, by struggling, filter through clapboards, two log walls, spikes, and rocks, to the gloomy interior. A pad-locked trapdoor in the floor above is the only entrance. The daily rations for ye solitary culprit, like all blessings, come from above—through the trapdoor. Here, suspected unfortunates of a desperate stripe awaiting trial, and convicted criminals, biding their day of departure for the penitentiary or gallows, are confined in dismal twilight, and in turn are raised by a summons from above, and a ladder cautiously lowered through the opening in the floor.*

William Faulkner himself would have relished that ornate description. Zeigler and Grosscup had no doubt read Ms. Davis's account of the Wayneville facility and wanted to outdo her, if possible. And in my estimation they did.

Boardinghouse Memories

A re there any honest-to-goodness boardinghouses still in operation here in Western North Carolina? There are, of course, hotels, inns, bed-and-breakfasts and motels galore. But I'm wondering about the genuine article: the old-fashioned boardinghouse that flourished throughout the region until the middle of the twentieth century.

Unlike the establishments just mentioned, a real boardinghouse had several distinctive features. It would often come into existence as an expansion of the proprietor's original home site; sometimes it was established in a renovated commercial structure of some sort. Rooms would sometimes be let out for overnight guests. For the most part, however, a boardinghouse catered to those staying for at least a week. And it wasn't unusual for them to stay either for an entire season or even on a permanent basis. Working-class guests were at least as common as vacationers. Long-term boarders were often adopted into the proprietor's extended family. Concern for their general welfare became a part of the boardinghouse's intricate web of socioeconomic relationships.

Family-style meals were the mainstay of a boardinghouse. Sometimes all three meals (breakfast, dinner and supper, as they are properly referred to in the South) were served each day—sometimes just breakfast and supper. The serving period for each meal was posted, and the proprietor expected boarders to be on time. Most guests honored this system as a matter of courtesy. They also realized that those arriving late had less—sometimes very little or nothing—to eat.

Some of the rooms had bath facilities. Those cost more. Most guests shared a bath, which always seemed to be located "just down there at the end of the hall." A guest taking too much time or using up all of the hot water would hear about it from his fellow guests. If the habit persisted, the proprietor would weigh in.

There was always a common sitting and reading room used primarily during the winter or just before meals were served. Whenever the weather was fine, there was always a broad front porch with the inevitable rocking chairs.

In my experience, the last true boardinghouse in Western North Carolina was the Swain Hotel, located on Everett Street in Bryson City. From 1967 until 1996, it was owned and operated by Mildred and V. L. Cope. Swain County native Luke Hyde, an attorney, purchased and renovated the establishment, opening it in 1997 as the Historic Calhoun Country Inn. Family-style meals are still served, but the current operation is not a true boardinghouse in most regards. Although many of the guests return from season to season, none is of the long-term or permanent variety. Most are vacationers.

"Until 1966 the business was known as the Calhoun Hotel," Hyde said. "It was operated by Granville Calhoun and his family. My mother worked at the Calhoun Hotel for thirty years. That's why I reverted to the old name.

"As far as I know the Swain Hotel as operated by the Copes was the last true boardinghouse west of Morganton. I stayed in a lot of places when I was looking for a suitable location of my own, and it was the only one I encountered.

"I remember when Mother, Alice Hyde, was working at the Calhoun Hotel that the Simonds family would come and stay for the summer. He operated a real estate business and had his business sign right there in the front yard. Mrs. Simonds operated a clothing store."

I stayed in the Swain Hotel on two occasions in the very early 1970s, shortly before deciding to move to Bryson City for good in 1973. For whatever reason, the memories of those visits—once by myself and once with my wife and our three children—remain vivid.

Mrs. Cope, who orchestrated the meals, had jet-black hair, powder-white skin and was something of a character. Her specialties were fried eggs and biscuits and gravy for breakfast; sliced cured ham, mashed potatoes and applesauce for dinner and pork tenderloin or chops, baked sweet potatoes and blackberry pie for supper. Fried chicken was reserved for Sunday dinners. Mr. Cope had only one arm but could perform almost any maintenance task with great dexterity.

All of our fellow guests were exceedingly cordial but not intrusive. Most were working-class and dressed accordingly for meals. One elderly couple dressed up for all meals. They were permanent residents. He was the only man in the dining room with a coat and tie.

Everyone got along. Everyone was exceedingly courteous about passing food and not taking too much. Personal matters, politics and religion were not discussed.

The weather was the primary topic at each meal, but hunting and fishing were well within bounds. Children were made over in a formal manner. The black-and-white TV in the sitting room was always turned off right after the late news.

All in all, in my experience, an old-fashioned boardinghouse provided the context for a functional and agreeable lifestyle.

Springs, Springboxes and Springhouses

Old-time mountaineers picked house sites according to the location and purity of springs. They were connoisseurs of water. Taste was the prime consideration, followed by coolness, clarity and reliability.

"There are older people to this day who will not drink city water, and who make regular pilgrimages…to fetch water from a favorite spring and take it home," observed Ed Trout in his *Historic Buildings of the Smokies* (1995).

Wilma Dykeman recorded in *The French Broad* (1955) that "when the buyers for the Great Smoky Park were appraising some of the small landholdings one old fellow would come down from his little farm each day.

"'When'll you be a-getting to my place,' he'd demand of the buyers.

"'We'll be up there as soon as we can,' they'd reply.

"'Well, I'm just aiming to make sure you see my spring,' he said. 'You'd have to see it afore you could know the worth of my place.'"

Once a family's prize spring was located, the women would sometimes line its sides and bottom with shards of quartz and other sparkling stones. Catching a shaft of light through an overhanging hemlock, the spring would glow in the dim light. It was a place of enduring sustenance and beauty.

"A spring issuing from the living rock is worthy of confidence," was the considered opinion of outdoorsman Horace Kephart. From 1904 to 1907 he resided in a remote cabin in what is now the Great Smoky Mountains National Park. In his *Camping and Woodcraft*, first published in two volumes

in 1906, Kephart provided a description of the springbox he constructed for use at that site.

"I had a springbox…which kept things cool and safe in the warmest weather, yet was easy for me to get into," he wrote. "A short iron pipe entered the spring; the box inclined slightly toward the outlet; pails and jars sat on flat rocks inside; the top was fastened by the round stick passing through the auger holes in the upright cleats."

Springhouses were normally small, low structures. Most were placed downstream from the springhead. Some had floors; many didn't. Instead of using boards for floors, some families chose to lay down stone slabs. Water flowed to and through them in various ways: rock-lined channels, elevated troughs and hollow logs. Crocks were placed in the water for food that required very cool conditions. Shelves along the interior walls provided storage space for other foods.

"Food was usually placed in heavy crocks capped with ceramic lids, boards, or flat rocks," observed Trout. "Canned foods and salted meat were also stored there. Sausage, wrapped in corn shucks, placed in a crock and sealed with fat, would keep through the summer in the springhouse."

When I was a boy, a springhead in a wooded ravine not too far from my house was my secret hideaway. I would go there to think and read and dream. It was my place of refuge. Moving water and dappled shadows and birdsong beckoned me toward an understanding of the natural world.

For more than a quarter of a century, my wife and I have lived in a secluded mountain cove. Until recently our primary supply of water was a spring situated at the foot of a giant hemlock outside our old cabin. The spring is contained by a galvanized washtub. A dipper hangs from a nail in the hemlock.

These days, we've gotten all newfangled. Water is gravity-fed into our newer home from a spring higher up on the ridge. A pipe leads a few feet from that new spring to a plastic barrel. A buried line leads from the barrel to the house. It's something of a novelty for us to turn a handle in the new house and get water.

But if that source ever fails, we'll just go back to hauling water from the old spring in a bucket. Even during the driest years, that spring never once failed us. It's the best water you ever tasted.

Goldenseal as a Medicinal

Arthritis, asthma and other congestions, bleeding from cuts and abrasions, blood pressure disorders, boils, broken bones, burns, chapped skin, chills, colds, colic, constipation and hemorrhoids, corns, cough, croup, diarrhea, diphtheria, dysentery, earache, eye disorders, fevers of various sorts, gunshot wounds, inflammations and/or itches in various places, measles, menstrual disorders, mumps, nerves, nosebleed, stopped-up noses, pimples, rabies, rheumatic fever, rheumatism, ringworm, scabies, scurvy, shingles, snake bites, sore throats, bee and other stings, stomachaches, syphilis, thrush, tonsillitis, toothaches, tumors of various sorts (including cancer), ulcers and warts.

In alphabetical order, those are but some of the physical maladies an early settler here in Western North Carolina might have had to contend with. People couldn't go to a local pharmacy, and until the early twentieth century, competent medical practitioners were few and far between. So folks had to pretty much grin and bear it or attempt to heal themselves via home remedies.

For the most part these remedies were based on medicinal plants. Settlers brought much medicinal lore with them from the Old World or other parts of America and adapted it, as best they could, to the local flora. And they learned a great deal about these plants and their potential uses from the Cherokees.

But it was a game of hit and miss, mostly the latter. A majority of the designated medicinal plants were, in reality, ineffectual, although they no doubt worked to a certain extent as placebos. Sometimes the supposed remedies were themselves

harmful, even to the point of being fatal. Nevertheless, the settlers would from time to time identify a plant that was at least potentially beneficial.

One of these was goldenseal (*Hydrastis canadensis*), also known as yellow puccoon or yellowroot (not to be confused with shrub-yellowroot, *Zanthorhiza simplicissima*, a very common streamside shrub). Would you know goldenseal if you saw it in the wild? It's a perennial herb about a foot tall found in rich, shady, upland woods. As with May-apple, the main stem is forked. One branch supports a large leaf while the other supports a smaller leaf and a delicate greenish-white flower that sets a dark red fruit in the fall. The bright yellow color of the roots is diagnostic. Its reputation for aiding ulcers, canker sores and other skin ailments (as a salve) and for being a beneficial stomach medicine (as a bitter tonic) is still current today.

In my opinion, the two-volume work by John K. Crellin and Jane Philpott titled *Herbal Medicine, Past and Present* (1989) is one of the cornerstones of bona fide Appalachian herbal lore. Therein, the authors, Crellin (a professor of medicinal history at Memorial University in Newfoundland) and Philpott (professor emerita in the Department of Botany and School of Forestry at Duke University), provide two entries for more than seven hundred species of Appalachian plants. The first entry for each species is "The Herbalist's Account," provided by A. L. "Tommie" Bass; the second is a "Commentary" by Crellin and Philpott, a summary of what they could find in the medical literature about the plant along with, sometimes, their observation that a given plant is promising and needs further study. Thereby, the reader obtains a balanced account from both ends of the spectrum.

Have you never heard of A. L. "Tommie" Bass of Leesburg, Alabama? He's one of the few herbal practitioners that I've ever put much stock in. After he passed away at the age of eighty-eight in 1996, a eulogy written by Crellin appeared in *HerbalGram: The Journal of the American Botanical Council*. Here's some of what he had to say in regard to his friend and informant:

> *"I try to give ease. Folks have called me a backwoodsman, or a mountain man, and I tell folks I'm a hillbilly without a guitar."*
>
> *Tommie Bass introduced himself in this way to hundreds upon hundreds of people who sought his help and advice…Bass's interest in herbs started early as, like his father, he followed a long Appalachian tradition of herb gathering and trading. A retentive memory and an eye for income fostered his growing knowledge, garnered from the oral and printed traditions. One of his early advertisements [in a farm bulletin] is typical of those he used for the next 30 years or so: "Wanted: Star of Grub root, Star grass root, lady Slipper, Snake root, Black Haw bark or root, Calamus and Bloodroot, etc. Write for prices—A. L. Bass, Leesburg."*
>
> *Although Bass's local reputation grew, it was only from the 1970s that he began to be widely sought after as an herbalist. The "ease" that Bass gave to many often rested on more than his extensive knowledge of herbs, though he never wanted to admit that. A meeting with him generally took place in his yard—which he aptly described as a junkyard—or inside*

his shack or on its porch. In the winter a coffee pot of warm sassafras tea standing on a stove greeted the visitor to a roomful of clutter…When visitors left, Bass's last comment was generally, "I'm sure glad you came."

Bass's advice for, say, such common problems as ulcers and rheumatism, was that he could provide relief ("ease") rather than a cure, and that the visitor would be a "guinea pig to see if the medicine works." Often no charge was made for the "trial" of medicine. If the medicine "worked," a repeat of the herbs or tea commonly cost one to two dollars.

Tommie Bass often said, "I can't quit jabbering." While we can no longer hear directly his wonderful story-telling, his own words and wisdom have been captured many times in the media (film, print, radio, and television) as well as in my Herbal Medicine, Past and Present *and my* Plain Southern Eating *(1988).*

If you get really interested in herbal lore, locate a copy of *Tommie Bass…Herb Doctor of Shinbone Ridge* (1988) by Darryl Patton. It's chock-full of Tommie Bass's medicinal lore and stories. A visit to see Tommie Bass no doubt made you feel better whether the remedy worked or not.

Let's take a look at the accounts from *Herbal Medicine, Past and Present* regarding goldenseal:

THE HERBALIST'S ACCOUNT: "Goldenseal is the king and queen of the herbs the good Lord put in the ground…The roots and tops are used to make a tea…It's used to make a laxative; mix with May-apple, black snakeroot, and dandelion root to balance…It can be used for anything that ails you…It is a tonic, a blood purifier, and it's good for ulcers, sores, and skin problems. You can use it for hemorrhoids…It has a tendency to be powerful and to have an aftereffect. I bought two pounds out of West Virginia about a year ago, and that will last a lifetime the way I use it."

THE COMMENTARY: "Hydrastis, or goldenseal, has undoubtedly been one of the most popular American indigenous remedies…[Its popularity] rests primarily on its well established reputation for aiding ulcers, canker sores, and other skin ailments. The constituent alkaloids possess similar properties and account for the reputation as a bitter tonic and stomach medicine…The use of hydrastis for treating wounds and skin ailments has been rationalized by the antibiotic action of berberine, but this property has not been tested in controlled clinical situations employing hydrastis extracts…Bass's views are generally in line with late 19th century recommendations. However, his statement that hydrastis is the king and queen of herbs seems an overstatement in light of its principal uses as a bitter tonic and for treating skin ailments. Other reported uses are much less well established, although the many pharmacological properties of berberine need study in a clinical context."

At one time goldenseal was fairly common throughout Western North Carolina. But because of its reputation as a medicinal, it was and still is extensively harvested for local use as well as for the drug market. (The income from selling the roots was

such that several of the rural families propagated goldenseal in the county where I live.) Currently, you aren't all that likely to find it in the wild. I've personally located but three sites in Western North Carolina where it was growing, and one of those was situated where it had been grown commercially during the early twentieth century.

Weather Sharps

Will it rain or shine tomorrow? Will it be a hot summer? When will the first killing frost be? Will it be a cold winter? How many heavy snowfalls will come?

These days the answers to such questions are the province of trained meteorologists on the local, regional and national level. But not so very long ago, the local weather sharp was relied upon to forecast the weather, good or bad.

Here in the mountains, weather sharps could be either male or female, but most were elderly men. They tended to be lean and spry. Hardly ever did one encounter a fat weather sharp. He or she had to be keen and alert to discern signs. Weather sharps, even those that were women, often smoked pipes. Smoking a pipe was meditative and helped the weather sharp contemplate the future.

Weather sharps were usually loners. They often lived in remote cabins. They were close to nature. They paid attention to the plants and animals. Being a local weather sharp was just about a full-time job. Here are the sorts of things that he or she had to know.

For short-term forecasts, weather sharps always watched their cats. If the cat sat with its back to a heat source, they anticipated cold weather. A cat that sat with its back to the wind also signified cold weather. If the cat frisked about the cabin, a bad storm was brewing.

Weather sharps knew for certain that it would soon rain when cows lay down in the pasture; smoke went to the ground; birds flew low or ants covered the holes of their hills.

To predict when the first killing frost would arrive each year, weather sharps listened closely to the katydids. They knew that the first killing frost would come exactly ninety days after the first katydids began to sing. They carefully circled that day on the calendars in their cabins.

Weather sharps also watched barnyard ducks when the pond froze over in early winter. If the ice would bear the duck, the rest of the winter would be slush and muck.

In the fall of the year, weather sharps were always being consulted as to how many winter snowstorms were coming. They relied upon a number of indicators.

They checked the date of the first snowfall deep enough for rabbit tracks. This clearly indicated the number of winter snowstorms of three inches or more ahead; for example, if the first snowfall came on November 6, six winter storms of three inches or more would come.

Weather sharps had to be good at counting. They counted the number of foggy mornings in August. This number always equaled the number of snowfalls for the following winter. They also counted the number of days from the first snowfall until Christmas. This number always equaled the number of snowfalls to expect afterward.

There were things about snowfalls in general that every weather sharp knew: whenever snow lies in drifts in the shade and refuses to melt, these drifts become "snow breeders" that attract more snow; whenever the sun shines while snow is falling, expect more snow very soon and whenever a dog howls at the moon, it signifies an early snow.

Predicting whether a coming winter would be cold or not was a local weather sharp's primary duty. His or her neighbors had to know how much wood to get up and how much food to put away. Accordingly, they had to consult a number of signs having to do with the plants and animals.

In regard to plants, sharps knew that the coming winter might be especially cold when moss grew on the south side of trees; fruit trees bloomed twice; blackberry blooms, holly berries and acorns were prolific; hickory nuts had a thick shell or onions grew more layers than usual.

In regard to the four-legged animals and the birds, they knew that the coming winter might be especially cold when the hair on bears, horses, mules, cows and dogs was thick early in the season; hoot owls called late in fall; juncos (snowbirds) fed up in the trees instead of on the ground; the breastbone of a fresh-cooked wild turkey was dark purple and squirrels grew bushier tails, built their nests low in trees, accumulated huge stores of nuts or buried the nuts deeply in the ground.

Insects were particularly significant when it came to forecasting winter weather. Weather sharps knew that the coming winter might be especially cold when ants built their hills high; hornets built their nests low or the fabled wooly worms were abundant, had heavy coats and displayed wide black bands on their backs. A really accomplished weather sharp could discern by the thickness of the black and tan bands of a wooly worm which weeks during the winter would be mild or harsh.

But come hell or high water, each and every weather sharp knew one thing for sure, which was this:

> *Whether the weather be fine*
> *Or whether the weather be not,*
> *Whether the weather be cold*
> *Or whether the weather be hot,*
> *We'll weather the weather*
> *Whatever the weather,*
> *Whether we like it or not.*

The Hermit of Bald Mountain: David Grier

Mountain landscapes throughout the world have many associations. One enduring notion is that mountains are places of refuge and isolation. And, at times, as with monks and hermits, mountains have been associated with total and long-lasting seclusion. There's been a seeking of refuge and even of isolation aplenty here in Western North Carolina, but where are the hermits? There seems to be a bothersome dearth of them in the cultural history of the region.

The Scotch-Irish and other early white settlers seem to have been seeking independent isolation of a sort as they filtered into the southern mountains. In his early study *Western North Carolina: A History (from 1730 to 1913)*, published in 1914, John Preston Arthur noted that "So sequestered were many of these mountain coves which lay off the main lines of travel, that persons living within only short distances of each other were as though 'oceans rolled between.'"

This is true enough, but it is also true that the early settlers were for the most part profoundly influenced by an ingrained sense of community. Every individual along a given watershed—no matter how ornery or aloof or semi-isolated he or she might be—was invariably a part of the human fabric of that specific area.

Sometimes an individual might disappear from a community for a while, taking, as it were, an extended leave of absence. Arthur cited the instance of one "Mont. Ray, who soon after the Civil War…killed Jack Brown of Ivy, between Ivy and Burnsville, and went to Buck's tanyard, just west of Carver's gap under the Roan mountain, where he supported himself making and mending shoes till many of

the most important witnesses against him had gotten beyond the jurisdiction of the court—by death or removal—when he returned and stood trial in Burnsville and was acquitted. He had never been forty miles away, had remained there twelve years; yet no one had suspected he was a fugitive from justice."

I repeat myself: accounts of isolation and even forced refuge are commonplace here in the Southern Appalachians, but where are the true hermits? For some years now, I've worried about this. It's an important issue. Almost all of the mountainous regions of the world have had a rich history of hermitism of one sort or another. Think of the plethora of hermits—old codgers like the immortal Ben Lily with mules and frying pans and a dozen or so hunting dogs—hiding away in the Rockies even now. And goodness knows, almost every mountain peak in the Himalayas seemingly has had a resident hermit, even though they called themselves monks.

Having searched high and wide, I've located a reference to but one recluse who seemingly qualifies as a genuine Western North Carolina hermit. His name was David Grier. His story was recorded by Silas McDowell, a nineteenth-century Macon County historian. McDowell's papers are housed in Special Collections at the University of North Carolina in Chapel Hill. Under the heading "The Hermit of Bald Mountain," Arthur provided a gloss of McDowell's notes pertaining to Grier, an instance of the hermit as rejected lover, not an uncommon category in hermit lore. "In Yancey County, visible from the Roan, and forty-five miles from Asheville, is a peak known as Grier's Bald, named in memory of David Grier, a hermit, who lived upon it for thirty-two years," Arthur summarized from McDowell.

> *A native of South Carolina, he came into the mountains in 1798, and made his home with Colonel David Vance, whose daughter he fell in love with. His suit was not encouraged; the young lady was married to another, and Grier, with mind evidently crazed, plunged into the wilderness. This was in 1802. On reaching the bald summit of the peak that now bears his name, he determined to erect a permanent lodge in one of the coves. He built a log house and cleared a tract of nine acres, subsisting in the meantime by hunting and on a portion of the $250 paid to him by Colonel Vance for his late services. He was twenty miles from a habitation. For years, he lived undisturbed; then settlers began to encroach on his wild domains.*

Alas, poor David Grier. Hermits don't like company. He killed one of his encroachers, one Holland Higgins, but was cleared on the grounds of insanity. Returning home from the trial, Grier was himself slain by one of Higgins's friends.

According to Arthur's rendering of McDowell's account, Grier, "after killing Higgins [had] published a pamphlet in justification of his act." And after his own death, "he left papers of interest, containing his own life's record and views of life in general, showing that he was a deist, and a believer in the right of every man to take the executive power of the law into his own hands."

For whatever reasons, violent endings are often the hermit's fate. It may be that martyrdom is the very thing that some of them are seeking in the first place.

The Calloway Sisters

Most everyone agrees that marriage is a noble institution. But even in the best of situations it can be, at times, a demanding proposition. Some folks seem to be especially star-crossed when it comes to matrimony. And have you ever noticed that extraordinary marital situations seem to run in certain families? Don't ask me why.

Behold, for instance, the Calloway sisters, who resided in Western North Carolina during the early nineteenth century. Fanny and Betsy Calloway were the daughters of Ben Calloway, one of the first settlers on the Watauga River in the northwestern corner of the state. Both sisters were celebrated for their grace and beauty. And both had unusually complicated spousal issues.

Fanny married John Holtsclaw, a Baptist preacher. They had seven children. Around 1825, Holtsclaw encountered Delilah Baird, the eighteen-year-old daughter of Colonel Bedent Baird of Valle Crucis. Delilah was willing to elope with Holtsclaw so long as they went somewhere far away like, say, Kentucky.

"Why certainly, Delilah, we shall go to Kentucky," Holtsclaw said, or something like that. He then proceeded to take her via horseback on such a roundabout and circuitous journey through the mountains in the immediate vicinity that the poor girl thought she had arrived in Kentucky. In reality, she was on the Big Bottoms of the Elk River, a mile from Banner Elk and only several miles from her childhood home.

Holtsclaw owned land along the river bottom and, with foresight, had already constructed their love nest. This was a camp, consisting of a bark structure built

against the trunk of a large fallen tree. And "for a long time this was their home. Their bed consisted of a heap of dry leaves and grass upon the ground; their stove was a crude furnace outside the door. Chairs? They were large stones. When Delilah wished to primp, her mirror was the placid water of Elk River."

Or so the story goes. We know that something like this took place, but just where fact leaves off and fable begins is difficult to discern. It was there on the Elk River that Delilah's first child, Alf Baird, was born. Alf is said to have been the first white child born in what is today Banner Elk. Later on the family moved into a rude cabin lower down the river, "where they settled in apparent harmony."

Delilah liked to dig ginseng in the fall of the year. One day when she had wandered far afield hunting 'sang roots, she heard a cowbell jingle, the first cowbell she had ever heard in "Kentucky." As she listened, it sounded more and more like the bell on Old Jers, her father's cow far away in North Carolina. Several days later she returned and followed the cow down a hollow and across a ridge, where, lo and behold, she found herself in her father's backyard at Valle Crucis!

Despite now being aware of her long deception, Delilah not only renewed her ties with her own family but continued to live with Holtsclaw, not in Kentucky, but just over the ridge from her home in Western North Carolina. In time he built her a fine white house overlooking the Big Bottoms of the Elk.

Fanny (nee Calloway) Holtsclaw, whose place Delilah had usurped, one day came to their door, asking to be allowed to spin, weave, wash, hoe or do anything that would provide John Holtsclaw's children with bread. No one knows how Delilah reacted. Holtsclaw's response was to deed all 480 acres of his Elk River land to Delilah and her descendants.But what goes around comes around. Among Fanny's children was a girl named Raney. One of her sons, James Whitehead, bought up all of the acreage Holtsclaw had deeded to Delilah.

We now return to Betsy Calloway, Fanny's sister. She was living at home in 1819 when a handsome fiddler and hunter named James Aldridge arrived in the community. (That he was a fiddler should have been a warning sign to the girl, but she was young and didn't know about wayfaring fiddlers.) He was attractive and appeared to be single. Soon, of course, they married and settled in a large cabin.

Everything went fine for about fifteen years. They had seven children. Then a fur trader named Price happened into the region. Price instantly recognized Aldridge as "Fiddling Jimmy." And, what's more, he knew Mrs. Aldridge number one, who, with their five children, was still living on the Big Sandy River on what was then the Kentucky-Virginia border (now West Virginia). When he went north again, he promptly shared news of his discovery with the original Mrs. Aldridge.

She soon appeared in Western North Carolina. Details of what transpired between the two Mrs. Aldridges are scant. It is recorded, however, that Fiddling Jimmy came by the local millhouse the day his first wife appeared and told the boys: "Well, the cat is out of the bag." Of Mrs. Aldridge number two, he said:

"She is sulky, but since I'm treating both women exactly alike [there's] no doubt she will get over it."

At some point after Mrs. Aldridge number one returned to the Big Sandy, several of her children by Fiddling Jimmy appeared on the scene in the Banner Elk area, further complicating matters. When relations between Mrs. Aldridge number two and Fiddling Jimmy cooled, he headed up to the Big Sandy to try to patch things up with the first Mrs. Aldridge.

This didn't work out either. When Mrs. Aldridge number two came north to check one last time on Fiddling Jimmy, she found him living with a young girl in a hut. She returned back to her home on the Elk River in Western North Carolina, where she managed to raise her own children and, from time to time, even the children from her husband's first marriage.

Let it be noted that the last entry I have located in regard to the life of Betsy Calloway (Mrs. Aldridge number two) reads: "She died in 1900 a well-respected woman."

(Sources for this account are John P. Arthur, *A History of Watauga County*; Horton Cooper, *The History of Avery County, North Carolina* and Carolyn Sakwoski, *Touring the Western North Carolina Backroads*.)

An Original Character: Quill Rose

Several years ago, my friend Lee Knight, an Appalachian folklorist and musician, and I went over the Smokies looking for a gravesite in East Tennessee. We had a tip that the subject of our inquiry was buried near Townsend. After several wrong turns, we located the cemetery and before long the tombstone in question, which read: "PVT / QUILL L ROSE / THOMAS' LEGION / LEVI'S BATT / NC LT ARTY / CSA / MAY 4, 1841 / NOV 3, 1921."

Lee and I are the charter (and only) members of the Quill Rose Fan Club & Memorial Association. We both enjoy reading and otherwise learning about the old-time "original characters" that flourished in the southern mountains, especially in Western North Carolina, during the last of the nineteenth and the first half of the twentieth centuries. Aquilla "Quill" Rose—Civil War veteran, fiddle player, storyteller, moonshiner and hunter—is surely one of the more picturesque characters ever produced in the region.

Quill served in the Thomas Legion during the Civil War, a unit formed by William "Little Will" Holland Thomas, the adopted son of the Cherokee leader Yonaguska, and himself a leader in tribal affairs throughout most of the nineteenth century. The Thomas Legion was jointly composed of white mountaineers and Cherokees. They didn't see too much action, but it must have been a most interesting experience for all involved.

In his *Western North Carolina: A History* (1914), John Preston Arthur devoted a paragraph to Quill, identifying him as a "picturesque blockader." Arthur noted

that "Soon after the Civil War he got in a row with a man named Rhodes a mile below Bryson City, and was shot through the body. As Rose fell, however, he managed to cut his antagonist with a knife, wounding him mortally. After this he went to Texas and stayed there some time, returning a few years later and settling with his faithful wife at his present home. It is near the Tennessee line, and if anyone were searching for an inaccessible place at that time he could not have improved on Quill's choice. He was never arrested for killing Rhodes, self-defense being too evident."

Quill also figured in Horace Kephart's *Our Southern Highlanders* (1913), wherein Kephart described the people living along the watersheds on the North Carolina side of the Great Smokies years before the park was founded in 1934. In depicting the nature of these settlements, Kephart noted that "All roads and trails 'wiggled and wingled around' so that some families were several miles from a neighbor. Fifteen homes had no wagon road and could be reached by no vehicle other than a narrow sled. Quill Rose had not even a sledpath, but journeyed full five miles to the nearest wagon road."

Quill lived on Eagle Creek—the mouth of which is between the mouth of Hazel Creek and what is now Fontana Dam—with Aunt Vice, his part-Cherokee wife. Eagle Creek before the turn of the century was, as Arthur indicated, remote, to put it mildly. Quill valued his privacy, and he didn't want any suspicious "revenue galoot" arriving at his place of business too quickly. If he heard from one of his lookouts that such a person was making his way up the creek, Quill would hightail it over the state line into Tennessee until things cooled off. At that time, he'd come back and commence his operation again. His motto was "never get ketched," an ideal that he failed to live up to on at least two occasions. To this day, the foundation of one of his block stillhouses is reputed to be up Eagle Creek "in some white pines."

Quill produced what he called tanglefoot on a large scale and got rid of the stuff fast. On being asked by a "furriner" if moonshine improved with age, Rose became incensed and emphatically denied it, citing his own research: "I kept some for a whole week one time and I could not tell that it was one bit better than when it was fresh and new." (As with most stories regarding Quill, there are several versions of this one.)

Kephart described Quill as an "original genius." Into the modern era, say up until the end of World War I, America specialized as a nation in producing a unique breed of citizen popularly categorized as an "original genius." Some had experienced formal education, but most hadn't. There were various sorts of original geniuses in America, depending on the locale. Here in the southern mountains, two distinctive types seem to have stood out. On the one hand, there was the practical individual who was self-reliant, indefatigable and exceedingly clever when it came to improvising and making do with little or nothing. On the

other, there was the flamboyant individual who, unlike most of his neighbors, wasn't shy in the least when it came to "showing out."

Quill Rose belonged firmly in the latter category. Whether riding his little white jackass (some say it was a mule) or sitting on his porch, Quill always carried his Winchester rifle on his arm. But he could be wonderfully friendly if he identified a visitor as a "gentleman," that is, someone other than "a sheriff's posse, the road-boss, or revenue galoots."

My favorite Quill Rose story involves his mighty fight to the death with a wolf. It's related in a long-neglected book by Wilbur Zeigler and Ben Grosscup titled *The Heart of the Alleghanies or Western North Carolina*, published in 1883. The authors had visited Quill on Eagle Creek to hunt deer. As they settled in to spend the night at his cabin, Quill obliged them with one of his tales:

> *"I was forced to cross a creek on some shelving rock above a waterfall," he recalled. "The rock was slick and I fell into a crevice, strikin' bottom on somethin' soft and hairy."*
>
> *"A wolf?" someone asked.*
>
> *"Yes, dog my skin!" Quill exclaimed. "Hit was the dry nest of a master old varmint under that fall. He was as fat as a bar jist shufflin' out o' winter 'quarters, an' he only had three legs. One gone at the knee. Chawed hit off, I reckon, to git shet o' a trap. Well the wolf snarled and struggled like mad, but I had the holt on 'im. I didn't dar' to lose my holt to git my knife, so I bent 'im down with my weight, and gittin' his head in the water drowned 'im in a few minutes. Then I toted and dragged 'im out to the dogs."*

Zeigler and Grosscup subsequently verified that the story was a true one, with the exception of one detail: in the telling of it, Quill had taken the place of the actual hunter who had encountered the wolf. There was, with Quill, always one last, unexpected twist to all of his tales.

Late in life, Quill violated his "eleventh commandment" and "got ketched" for doing what he did with corn and was hauled before a federal judge in Asheville.

"Come here, Quill Rose," the judge ordered, "stand up here and plead guilty or not guilty."

Quill, being the sort of fellow he was, took his own good time before finally standing up, paused for a while as if mulling over his choices, looked at the judge and said, "Maybe."

Bryson City Island:
Ironfoot Clarke's Abode

I generally enjoy working in my office, which is situated off the town square in Bryson City. But I find it's sometimes worthwhile to get away, if only for a few minutes. Just shut down the computer, turn out the lights, lock the door and take a walk. Get away, as they say, from it all.

My footsteps invariably lead north up Everett Street and across the bridge over the Tuckasegee River. I always pause and look down into the water. When it's clear, you can catch glimpses of the occasional red horse, smallmouth bass, bream or trout hovering in eddies over the sandy bottom. It's sort of like looking down into a natural aquarium from above. Very soothing.

Next, I turn east down a side street on the far side of the river. A short stroll takes me to a 7-acre tract now known as Bryson City Island Park, situated near the railway depot. The island, which is maintained by the Swain County Parks and Recreation Department, is presently accessed via a 150-foot swinging bridge that traverses a side channel of the river.

There's a loop trail on the island that meanders beneath very large holly, oak, tulip poplar and sycamore trees. Most of the time I have the entire island to myself, especially in winter. I feel fortunate. After all, not many people can leave their office and within a few minutes escape via a swinging bridge to the solitude of a nearby island.

I wouldn't, in fact, mind living on just such an island. That's not possible, of course, as it's publicly owned. But a man—a hermit of sorts, although he resided in

the midst of a community—did live there in a shack during the early years of the twentieth century. At that time the island didn't have a name or a swinging bridge. From time to time, I like to think about that gentleman and his island abode.

His name was Ironfoot Clarke. Not too much is known about Ironfoot. I became aware of him some thirty years ago through vague allusions circulating among old-timers in Swain County. I talked to many of those older folks, mostly now deceased, and scribbled down the following notes regarding Ironfoot.

"Yes, that's correct," Buddy Abbott recalled, with a twinkle in his eye, "he did live on that island. I saw him, but I don't remember his real given name. He had an artificial foot. That much is certain. The story goes that he was a part of the James Gang and rode with Jesse James. That's what I heard as a boy growing up. Ironfoot got his foot shot off in a train robbery was what they said. Then he came here to Bryson City and lived on that island. That's the story. I didn't camp out there until after he was gone, but even then I was apprehensive."

Other longtime residents added bits and pieces to my Ironfoot file. Hazel Fry Sandlin came to town from the Nantahala Gorge in 1914 as an eleven-year-old. She recalled that Ironfoot's last name was Clarke and that he was buried "west of town," but I haven't been able to locate his last resting place.

"Oh yes," she said, "he had a saddle stirrup attached to his leg where he'd lost that foot. Mr. Clarke never gave anybody any trouble, but our parents didn't want us near the island because of the dangerous currents, so they told us tales about Ironfoot that made you stay on solid ground. No, I've never set foot on that island, even though I can see it from my front porch right now."

At the time I was conducting my Ironfoot research, Virginia Freck lived in the house in which she had been born, which was, as she put it, "within spittin' distance" of the island.

"Mr. Clarke lived by himself over there in a house that people these days would call a shack," she recalled. "It was his home. People said he had been an engineer for the James Gang. I supposed that maybe he sometimes drove the trains they robbed, if need be. That sort of engineer. I don't know.

"Mr. Clarke was all right. Sometimes he would get flooded out of his shack by the river. Then he'd have to climb way up in that big tree over there on the island in order to save himself. Folks would send him food across the water on a wire that was specially attached to the tree for these occasions. He would have to remain in the tree until the water subsided. Then he would come down and go about his business, whatever that was."

I've never discovered what his business was either. My best guess is that Ironfoot didn't have any business, except that provided by living on a semi-isolated island in the mountains. To my way of thinking, it was a pretty good business. One could do worse.

What's in a Name?
Turkey George Palmer

The most interesting nicknames generally have to do with incidents in a person's life. Quite often, the origins of a nickname will be in dispute so that there will be variant versions. And sometimes these stories will enter the realm of the tall tale. Take the case of old-time Cataloochee Valley resident George Palmer. His nickname was "Turkey George."

To get to Turkey George's old home place, now situated in the Great Smoky Mountains National Park, go to Cataloochee Valley in Haywood County and locate the terminus of the Pretty Hollow Gap Trail in the area of the horse camp across from the old Beech Grove School. Walk along this trail about seven-tenths of a mile until you encounter an open field on the left. Apple trees, yucca and other plants indicate the presence of a former home site. Turkey George's place comprised a house, a springhouse, a smokehouse, a barn and sheds for sheep and other livestock.

His name pops up in all of the accounts of Cataloochee's human history. He was one of those great "original" homegrown characters like Wid Medford, Quill Rose, Mark Cathey, Samuel J. Hunnicutt and Pearly Kirkland that the Smokies region specialized in producing until the coming of the park in 1934. He wasn't flamboyant, but folks always remembered his impish smile and matter-of-fact way of telling a story.

When called upon to describe his neighbor Clay Batchelder with a hangover, he thought for a while and replied, "His eyes looked like a red fox's ass in a pokeberry patch!"

Turkey George was noted for always walking beside a horse named Sank, which he never mounted. He wore a handmade denim knapsack round his neck all clutched up against his chest, instead of wearing it on his back. He and Sank would sometimes walk to Waynesville and back in this manner. That's almost fifty miles.

Along with Wid Medford, another Haywood County native, Turkey George was one of the finest bear hunters ever produced in Western North Carolina. His son Robert "Booger" Palmer remembered that although his father sometimes hunted with an old muzzleloader, a rifle or a pistol, the majority of his bears were trapped. His favorite trapping ground was on Big Butt Mountain between Beech Creek and Pretty Hollow Creek. Most of the traps weighed about fifty pounds, but one that he called Grizzly Trap weighed close to eighty pounds. Some sources state that Turkey George killed 105 bears in his lifetime. Others credit him with 106. At any rate, his daughter, Flora Palmer Medford, recalled that her father's coffin was a steel casket purchased in Waynesville. He had requested this extra security as a precaution against being dug up by the bears in revenge.

Although he purchased a farm in Clyde, just west of Waynesville, for his family, Turkey George never moved out of Cataloochee, not even after the arrival of the park. The family remained there with him until his death in 1939.

Since we're thinking about nicknames, it'd be an oversight not to relate the origin of Turkey George's son's nickname. As Blind Sam Sutton remembered it, Robert "Booger" Palmer was just a bashful schoolboy when his teacher asked him what he wanted to be when he grew up.

"I want to be the boogerman," he said.

"Don't you want to be something else besides the boogerman?" she asked.

"No," he insisted. "That's what I want to be."

The name stuck; indeed, it's memorialized by the Boogerman Trail, which passes right by his old home site in the present-day national park.

Now we get to George Palmer's nickname. Hattie Caldwell Davis noted in her *Cataloochee Valley: Vanished Settlements of the Great Smoky Mountains* (1997) that he required a nickname because there were two other Georges living in Cataloochee. They were differentiated via the nicknames Creek George Palmer and Big George Caldwell.

The folklorist Joseph Hall once asked Turkey George himself how he came by the nickname.

"I had a patch of land in corn," he responded. "The wild turkeys was about to eat it up, so I built a pen to try to catch them…then I cut a ditch and run it into the pen and covered the ditch with bark. I scattered the corn in the ditch so as to draw the turkeys into the pen. Next mornin' they was nine big gobblers inside, an' one outside. I stopped up the hole an' got me a big stick to kill 'em with. When I got in the pen, they riz up and mighty nigh killed me instead—so I got out and fetched a hoe. When they stuck their heads betwixt the slats I knocked them with it. After

that I built about three pens in the mountains an' caught two or three turkeys. That's why they call me 'Turkey George,' I reckon."

Sometimes an individual acquires such a bigger-than-life reputation in a community that straightforward accounts regarding his or her life are no longer sufficient. Turkey George had achieved that sort of status in old Cataloochee. Here's yet another version for the origin of his nickname that Hall collected:

> *Uncle Levi Caldwell, the genial blacksmith of the Mt. Sterling Civilian Conservation Corps Side Camp in Cataloochee, told me how Palmer was walking on the mountain without a gun and saw "a gang o' wild turkeys. He tried to catch one and chased it as it fluttered along. Finally he managed to grab hold of one of its legs, but as he did so, the turkey riz in the air and carried him across a swag to the next mountain and courteously dropped him there."*

Fly Fisherman Extraordinaire: Mark Cathey

Want to start an argument? Go into a barbershop or sporting goods store here in Western North Carolina and strike up a discussion about hunting or fishing. Then proceed to have an opinion as to the best hunter or best fisherman yet produced in the region. Each town and village will have local favorites. In the Smokies area, no one doubts that the legendary Mark Cathey was hands down one of the finest hunters and clearly the most adroit fisherman yet produced. And he is equally renowned as a colorful character about whom countless stories are related. Eyes light up with warmth and humor when Uncle Mark, as he was known to relatives and nonrelatives alike, is remembered.

William Marcus Cathey was born on Conley Creek near Whittier in eastern Swain County in 1871. But he lived most of his life on Indian Creek, a tributary of Deep Creek in the present-day Great Smoky Mountains National Park, about four miles north of Bryson City. He earned his living as a lumber-herder, trapper and hunting and fishing guide. When the splash dams on the creeks in the Smokies were released, lumber-herders ran along the banks to clear jams. Some few, like Cathey, were known as timber-doodles because they had the agility and courage to ride the logs down the creek while standing up, ducking branches and risking sure death in the event of a miscue.

"Physically," one contemporary recalled, "he was lean and lank, but not tall, and withal as tough as a mountain hickory. He was the nervous, wiry type. He had piercing eyes. He had an innate courtesy and refinement about him."

"When I was twelve, Father gave me an old muzzle-loading rifle, and it was with this rifle that I helped kill my first bear," Cathey recalled in his later years. "Since then I've killed or helped kill a passel of them. I know I killed fifty-seven myself and perhaps more. I killed my biggest bear at the Bryson Place on Deep Creek. It weighed five hundred pounds dressed. I saw this bear come over the top from Tennessee. The dogs closed in and it was a terrible fight."

As a trout fisherman, Cathey was without peer. Folks came from all over the country just to watch him fish. His favorite fly was a yellow-bodied gray hackle. He perfected a method of "skippety-hopping" the fly on the surface of a stream in a dance that drove trout into a feeding frenzy.

"When we'd make camp, I'd put a pot of water on for coffee," a friend remembered, "and Mark'd be back with enough trout to feed five men before the water could boil."

Cathey was a modest man, but he would allow that "I have been accused of being the best fisherman in the Smokies."

He spoke in a musical drawl that was memorable. One listener noted that "He sounded like W. C. Fields with an Irish accent."

Uncle Mark Cathey stories abound. Here are a few.

One visiting fisherman spent the day with only two small trout to show for his efforts. Encountering Cathey, he asked, "How many did you get?"

"My basket is empty," came his reply.

"Well, I'm not surprised," the visitor replied.

"But I ain't fished as yet," Cathey replied and proceeded to use the sorriest fly the other fisherman could come up with to catch his "leemit."

Another outsider, all duded up in spiffy outdoor clothes and carrying a huge bowie knife, caught a small trout that he reeled in to the very tip of his rod.

"Sir, I have caught a fish," he said to Cathey, his guide, "what do I do now?"

"Sir, climb out there on that pole and stob that there fish to death with that bowie knife," he responded.

After getting caught in one of his own traps, Cathey observed sheepishly, "Well, it wasn't such a good trap or I couldn't have got out."

Served raisin bran for the first time in his life, Cathey immediately commenced spitting raisins and exclaimed, "By gad! There's been a damn mouse in the bran!"

Snowbound with friends in a shack in the high Smokies, Cathey was asked how cold it was. After going outside for a while, he returned and reported, "Boys, I can't rightly tell. I hung a thermometer on the nail outside the door, but the mercury dropped so fast it jerked the nail right out of the post. Apparently it's cold."

In 1938, some Asheville friends told an agent for the famous movie cowboy Tim McCoy that Cathey was just the man to handle a team of oxen in a western being filmed at that time. The agent journeyed to Bryson City twice but was turned down each time in his efforts to lure Cathey away to Hollywood.

"I love the Smokies too much to leave them," he explained. "Why, I'm at home in the Smokies. I've traveled about some and this is the best country I've found."

One afternoon in October 1944, Uncle Mark left his sister's house on Hughes Branch, where he then lived, to hunt a squirrel. His sister had requested one to go with some sweet potatoes she was preparing for dinner. When he failed to return by dark, a search party was formed. He was found about midnight, sitting under a large oak, his rifle across his lap, his dog by his side, the victim of a heart seizure. The epitaph on his tombstone in the cemetery overlooking Bryson City, with its characteristic touch of warmth and humor, seems fitting:

> *Beloved Hunter and Fisherman*
> *Was himself caught by the Gospel Hook just*
> *Before the season closed for good.*

(Sources for this account are photocopies of various clippings provided by Cathey's descendents in the 1980s and this writer's biographical profile of Mark Cathey in *The Heritage of Swain County, North Carolina.*)

High Vistas:
Pearly Kirkland,
Fire Tower Dispatcher

Like many, I'm an aficionado of the high natural vistas that abound here in Western North Carolina. Accordingly, I'm also interested in the fire towers that sit atop numerous peaks throughout the region.

Lots of people like to study those molded relief maps of the region—the ones that show the upraised contours of the mountain ranges. Some, like myself, have even pieced together the relief maps for all of Western North Carolina as a wall hanging, making it possible to contemplate in miniature the glorious terrain we call home.

It's pleasurable to sit in an easy chair on a rainy day and ponder the way the ridges join or to meditate as to how they might have looked before eons of erosion wore them down into their present configuration. Even more rewarding is a venture to a local vista for a panoramic look-see at the real thing.

In one sense, of course, high vistas are places that enable us to rise above our everyday humdrum existence and take in grand scenery, even when we don't know exactly what we're looking at. As one writer aptly phrased it, "There's wonder and delight up there…elbow room for the soul…all you have to do is suspend judgment and analysis long enough simply to be there, on the mountain, experiencing it."

High vistas are windows that allow us to see and comprehend more truly. From late fall into early spring, before foliage softens the landscape and summer's heat brings up shrouding mists, you can observe the bare bones of the land and come to a fuller understanding of the exact lay of the land. From a strategically located vista, you

will be able to observe just where the major ranges abut and how the peaks, spurs, gaps, upland valleys, streams, rock cliffs, gorges, laurel hells and other topographical features all fall into place. You will come away with a clearer idea of your place in the world—and maybe even a more precise notion of just who you are.

I've always sort of envied fire tower wardens and talked with them whenever possible. To a man (and woman) they have always presented themselves as down-to-earth sorts who do not romanticize their work in the least bit. I suspect, however, that more than one of them is, in reality, a closet romantic.

In the late 1980s, I heard about and contacted a former fire warden named Pearly Kirkland at his home way down in the South Skeenah community, which is situated just a ways down the road from the North Skeenah and Middle Skeenah communities, several miles south of Franklin in Macon County. (William S. Powell's *North Carolina Gazetteer* defines *Skeenah* as a Cherokee word that means something like "abode of Satan," which hardly seems an apt description of the lovely rolling countryside in which those communities are situated.)

How Pearly, a Swain County native who was eighty-eight when I visited him, came to live down in South Skeenah is a story that's interwoven with his experiences as a longtime fire tower dispatcher at three high-elevation sites in Western North Carolina. On that bright autumn day many years ago, as the memories slowly flooded his mind, Pearly relaxed on his front porch, talking and laughing about the old days "up on the mountain at the top of the world."

"I was born on Chambers Creek in what now is the national park," he said. "My father, Albert, was from Bear Creek, and my mother, Dolly, was from Bone Valley on Hazel Creek, both places also being in the Smokies. I went to the Chambers Creek School, which was a church house, but I was mainly interested in the outdoors, in hunting and fishing and walking around.

"Jack, one of my brothers, became a park ranger at Forney Creek and that's how I got into the fire tower business. I'd been a logger at $1.50 a day, $.75 of which went for board, so, when Jack helped me get the job, I readily agreed to go up and be a park service lookout from the fire tower at High Rocks, which paid a little more and wasn't such hard work. High Rocks is an outlook on Welch Ridge between Hazel and Forney creeks. You can see all the south end of the North Carolina side of the Smokies from there and way off into the Nantahalas towards Georgia.

"I walked up to the tower from Chambers Creek and lived up in the thing. What did I eat? Why, I just ate rough rations—whatever was easy to fix because I had to carry the food up with me on my back on a pretty steep trail. I'd stay there through the fire season until it got wet enough to come down.

"That's where I picked up the habit of talking to myself. No one else up there except the bears, so I just got to talking to myself about this and that. I still talk with myself about the same things. Never have broke that habit. You get pretty much lonely in a tower during a long dry spell of nobody to talk to.

"The bears was a bother up there at High Rocks. Scared me some. They would come and break the windows out trying to get into the little cabin situated below the tower. So we put up wooden shutters.

"I was at High Rocks for about three and a half years or so, beginning in the early 1940s, as I remember. The last time I was up at the tower was when they were flooding Lake Fontana. When I came down from the tower, the lake was flooded and everybody had left Chambers Creek, which was now isolated along the north shore.

"Why, my wife and family had up and moved and I didn't even know where I lived! It took me a while to find out they were down here in South Skeenah, which is where we've been ever since. My wife, Hattie, was a Woody from Forney Creek. She died three years ago. We raised seven children.

"Then I was several years at Albert Mountain here in Macon County between Bearpen Gap and the head of Hurricane Creek on [U.S.] Forest Service land. That was where I got my biggest scare. A storm came up that was awful. Lightning was everywhere and constant. It was kindly eerie. Oh my gosh, I'm not exaggerating: the bolts would strike the tower, and balls of fire just flowed down the wires that grounded the tower. They lit up everything like pure daylight.

"From Albert Mountain the forest service moved me as dispatcher over to the tower at Cowee Bald, which is located in Macon County near where it corners with Jackson and Swain in the Big Laurel country. I was ten years at Cowee, which I liked best because it was the easiest to get to.

"Did I like it up there in those towers? Why no, I didn't. It was lonely with no family and nobody to talk with. To me it was just a job. When I went up to High Rocks it was hard times and fire tower work was just a way to make some money and support your family. That's all. No sir, I don't recollect anything romantic about it whatsoever."

Thomas Wolfe's Angel:
Hendersonville or Bryson City?

"Despite the evidence, the sentiment persists, even among some scholars, that the angel on the porch alighted from her stony flight in Hendersonville. Her remote sister remains undisturbed in Bryson City. Below her perch, the Tuckasegee River rolls untroubled; the tourist train rumbles, the town bustles with traffic, with its temporal small victories and woes. She stands as Thomas Wolfe wrote of Eugene Gant in the closing sentence of Look Homeward, Angel, *oblivious toward town and turmoil, pride and loss, her face toward 'the distant, soaring ranges.'"*

 Dot Jackson, "In Search of the Angelic Muse" (*The Independent Weekly, n.d.*)

In the late 1940s, research by the respected Asheville librarian and Thomas Wolfe scholar Myra Champion seemed to establish that, among the many candidates spread throughout Western North Carolina, a stone angel situated in Hendersonville's Oakdale Cemetery was the one Wolfe had in mind as a model when he wrote *Look Homeward, Angel*, his most famous novel. Most Wolfe admirers and scholars have through the years accepted that verdict.

But Mrs. Champion—as she informed this writer in a telephone interview shortly before her death in the late 1980s—didn't know, when she was canvassing Western North Carolina's graveyards for angels nearly half a century ago, about a haunting weather-darkened, fly-specked stone effigy in the old cemetery overlooking downtown Bryson City. Brought here from Asheville after the turn of the century by Tom's father, this Swain County angel seemingly corresponds more fully to the few details known about the novelist's angel than the Henderson County candidate.

(I first wrote about the Bryson City angel in an article that appeared in *Smoky Mountains Neighbors*, a supplement published by the *Asheville Citizen-Times* in 1990. Since that time, I've returned to the topic on several occasions in several publications, most recently via a "Back Then" column in the *Smoky Mountain News*, which I've augmented for publication here.)

Wolfe's father, W.O. Wolfe (1851–1922), operated a monument shop on Pack Square in Asheville from the mid-1890s until 1916. He did engraving and some rough stone carving, even attempting his own stone angels, but never apparently to anyone's satisfaction. The fine angels he marketed were sculpted in Italy from white marble extracted from the famous Carrara quarries. These arrived in Asheville via rail after having been shipped to New York and Philadelphia as ballast in the holds of ships. Through the years, Mr. Wolfe generally had several angels at a time on display in front of his shop priced in the four-hundred- to one-thousand-dollar range.

Accordingly, from the time Tom Wolfe (1900–1938) was born until he departed Asheville for Chapel Hill to attend the University of North Carolina in 1915, he had ample opportunity to view and contemplate a variety of these brooding figures. In retrospect, it's not surprising that one appeared in the short story "An Angel on the Porch," published in 1929 in *Scribner's Magazine*:

> *For six years it had stood on the porch weathering in all the wind and rain. But it had come from Carrara in Italy, and it held a stone lily delicately in one hand. The other hand was lifted in benediction, it was poised clumsily upon the ball of one phthisic foot, and its stupid white face wore a smile of soft stone idiocy.*

Shortly thereafter in this story, the additional detail is added that the angel "leered vacantly down." The magazine story description was incorporated into the novel *Look Homeward, Angel* when it was published in the fall of 1929. Ever since, people have quite naturally wondered about the exact identity and location of Wolfe's angel. His mother, Julia Westall Wolfe (1861–1946), recalled, when queried about the angel by Hayden North, author of *The Marble Man's Wife: Thomas Wolfe's Mother* (1947), that "some wealthy man from a nearby town bought it for his daughter."

This leaves us with the following definite (if meager) points of reference in regard to the most famous stone angel in American literature: it was executed from marble quarried at Carrara, Italy; it is poised upon the ball of one foot, looking downward; one hand is upraised in benediction while the other holds a stone lily and a wealthy man in a nearby town bought it to mark his daughter's gravesite. Also keep in mind that Wolfe rather curiously described the angel's foot as being phthisic, which would, according to the *Oxford English Dictionary*, imply a general wasting away due to "pulmonary consumption" (i.e., tuberculosis).

After locating and viewing as many of W.O. Wolfe's stone angels distributed at various cemeteries throughout Western North Carolina as she could, Champion declared in 1949—in a widely circulated newspaper story written by Virginia T. Lathrop titled "Hendersonville Monument Identified as Thomas Wolfe's

'Angel'"—that the Hendersonville angel was the most likely candidate. It marks the grave of Mrs. Margaret Bates Johnson (1832–1903).

But, alas, that angel's provenance seemingly doesn't fit the points of reference cited earlier: Mrs. Johnson was seventy-one years old at the time of her death; both her father and husband were dead and the angel's purchase was negotiated by her children. (The tombstone is inscribed "Our Mother.") Furthermore, that angel is carrying a shock of wheat.

As indicated previously, the only Wolfe angel in Western North Carolina that fully conforms to the details described in his short story and novel, as well as to his mother's recollections, is in Bryson City. Mrs. Champion advised me that she had not known at the time of her investigation about a Wolfe angel in Bryson City, although she had traveled "on a hot tip" to the nearby Whittier cemetery to look at one that "wasn't even close."

(Excellent images of nine of the Wolfe angels, including the ones at Hendersonville and Bryson City, were prepared by Helgar Bessent for a retrospective titled "Thomas Wolfe's Angels: A Photographic Odyssey," which was mounted in 2000 to honor the one hundredth anniversary of the novelist's birth. The website's address is provided in my list of sources along with the "Bessent" entry.)

The Bryson City angel marks the grave of Fannie Everett Clancy (1884–1904), a young daughter of Epp Everett, one of the town's more influential and wealthy residents. Bryson City resident Fannie Leatherwood, who was intimate with the Everett family, told me before she passed away in 1987 that Mr. Everett was severely grieved by Fannie's death from tuberculosis shortly after her marriage to one Ernest Clancy. This angel, with one hand uplifted, as if in benediction, is carrying in her other hand a stone lily.

"Mr. Everett purchased the angel from Mr. Wolfe in Asheville a while after her burial and had the foundation laid before Mr. Wolfe brought it over by train about 1907," recalled Mrs. Leatherwood, in a 1986 interview with this writer at her residence. Also present at the time were her daughter, Mary Nell Leatherwood, now deceased, and her former daughter-in-law Mercedith Bacon.

"It was sometimes the custom then not to erect monuments until after some time had passed," Mrs. Leatherwood recalled. "I do remember what a great occasion it was and that much of the town turned out to see Mr. Wolfe supervise the transportation of the angel in a wagon up the hill from the depot to the cemetery. A year or so later, the tip of one of the angel's fingers was shot off by some mischievous boys, who were sorely punished, but it has suffered no damage since, except that it probably needs a good scrubbing."

Other anecdotal evidence from various sources confirms that W.O. Wolfe brought the angel here on the train but adds no new detail except that he had little to say other than to severely curse the briars that had grown up along the hillside road leading up to the cemetery.

For the senior Wolfe, the journey by rail from Asheville to Bryson City was simply a matter of fulfilling a business transaction. For fans of his son's novel, one of the masterpieces of early twentieth-century American literature, it's a matter of more than passing interest.

So, where are we? It seems probable that Thomas Wolfe had a composite of the looming angels he had viewed during his youth in mind when he put pen to paper rather than just one. After all, at least fifteen such angels had passed across his father's porch during his formative years.

But in the event of a renewed Wolfe angel debate that attempts to bestow literary laurels on a specific monument, this lovely effigy overlooking Bryson City clearly has to be the prime candidate. One glance at her and you comprehend quite clearly why the son was haunted by his father's angels.

Horace Kephart: Outdoorsman, Writer and Park Advocate

After Thomas Wolfe, Horace Kephart (1862–1931) is perhaps the writer most closely associated in the national consciousness with the mountains of Western North Carolina. *Our Southern Highlanders*—first published in 1913, with an expanded edition in 1922—is considered by many to be one of the cornerstones of Southern Appalachian literature. Kephart is certainly the most famous outdoorsman the region has yet produced. His *Camping and Woodcraft* is securely established as one of the classics of American outdoor writing, having been continuously in print since 1906. And aside from his literary career, Kephart is widely recognized as one of the forces behind the founding of the Great Smoky Mountains National Park.

Evidence of Kephart's influence continues to this day. In 1994, he was featured in the park's sixtieth anniversary celebrations. In 2000, he was chosen by the *Raleigh News and Observer* as one of North Carolina's 100 Most Influential People of the Century while the *Asheville Citizen-Times* named him one of Western North Carolina's 50 Most Influential People of the Century, noting that after arriving in the southern mountains he "became one of the region's greatest advocates."

In 2002, filmmaker Paul Bonesteel premiered *The Mystery of George Masa*, an exceptionally well researched and produced documentary—which aired nationally via the Public Broadcasting System—about the life of Kephart's friend that explored their close relationship and dual roles in the founding of the national park.

In 2004, the Together We Read program in Western North Carolina chose *Our Southern Highlanders* as its topic volume. Entering its third year, this program's mission

is "to develop in the region a love of reading through the shared experience of well-chosen books." Sponsored by a number of regional agencies and institutions, the program is governed by a board of educators, librarians, business leaders and readers. During the last six months of 2004, a number of programs were presented throughout Western North Carolina depicting and celebrating Kephart's life, writings and role in the park's founding.

In conjunction with the Together We Read activities, I wrote a series of "Back Then" columns focusing on Kephart's life and work. In some ways, these expanded upon both the content and the perspectives that appeared in the biographical introduction I wrote for the reissue of *Our Southern Highlanders*, published by the University of Tennessee Press in 1976. For this *Mountain Passages* collection, I've compressed the contents of those columns to emphasize the seminal years when he lived alone in a cabin on a tributary of Hazel Creek in the Smokies (1904–7), his life as a citizen of Swain County and Bryson City (1910–31), specific incidents surrounding his death in an automobile accident as related by an observer (1931) and his role in the park movement (1923–31).

Horace Kephart stepped off the train at Dillsboro, North Carolina, one day in the early summer of 1904. Still a relatively young man, Kephart left behind a botched career as a librarian in Saint Louis, an estranged wife and their six children, and an aborted suicide attempt. All of the details of the events that sparked this midlife crisis are not fully known or agreed upon, but it's widely recognized that chronic alcoholism was a contributing factor.

Kephart came south into the Smokies region twenty years before the national park was established, looking, as he phrased it, for a "Back of Beyond," a place where he could "begin again." He was deliberately seeking a way of life similar to the one he had experienced as a child growing up in rural Pennsylvania and, subsequently, on a farm in Iowa during the 1860s and very early 1870s. He later wrote that he had wanted "to realize the past in the present, seeing with my own eyes what life must have been to my pioneer ancestors of a century or two before." And he arrived sensing that in some way this sort of venture—living among and writing about the people and places of the mountain region—could become part of a healing process.

From Dillsboro, Kephart walked west along the railway line for a mile or so before turning north up Dicks Creek. Here he obtained permission from a local family to pitch camp for the summer. By the fall of 1904, he had discovered the rugged, backwoods settlements along Hazel Creek, "far up under the lee of those Smoky Mountains," and secured permission from a copper mining company that had gone into litigation to use one of its abandoned cabins.

Located about two miles from Medlin, a tiny settlement situated where the Sugar Fork enters Hazel Creek about ten miles up Hazel Creek from its confluence with the Little Tennessee River (now inundated by Lake Fontana), this remote cabin site on "the Little Fork of the Sugar Fork of Hazel Creek" became the vantage point from which Kephart studied the land and its people.

It was a two-room structure, half of logs and half of rough planking, probably with two levels that were constructed at different times. He refurbished the dwelling, adding his few belongings, including a small library he hauled up to the cabin in a wagon. He commenced exploring his rugged surroundings. In time, he also entered into the lives of the two hundred or so native mountaineers that lived along the main Hazel Creek watershed and its ever branching tributaries.

One of the most revealing sources in regard to Kephart's years at the cabin is an interview conducted by F. A. Behymer, which was published in 1926 by the *St. Louis Post-Dispatch* under the heading "Horace Kephart, Driven from Library by Broken Health, Reborn in Woods." Behymer, who apparently knew Kephart from days together in Saint Louis, visited Kephart in his office just off the town square in Bryson City.

"'Seldom during those three years as a forest exile,' Kephart said, 'did I feel lonesome in the daytime; but when supper would be over and black night closed in on my hermitage, and the owls began calling all the blue devils of the woods, one needed some indoor occupation to keep him in good cheer.'

"It was the old life calling, the life of books that he had left," Behymer noted. "For such a man there could be a beginning again but the old life could not be entirely disowned...Out of the thousands of books that he had intimately known [as a librarian] there were only a few he could carry with him into the solitudes. He selected them with care, twenty of them. Here is the list in the order in which they stood on a shelf on his soap-box cupboard: an English dictionary; *Roget's Thesaurus*; his sister's *Bible*; Shakespeare; Burns' *Poems*; Dante (in Italian); Goethe's *Faust*; Poe's *Tales*; Stevenson's *Kidnapped*, *David Balfour* and *The Merry Men*; Fisher's *Universal History*; Nessmuk's [i.e., George Washington Sears] *Woodcraft*; Frazer's *Minerals*; Jordan's *Vertebrate Animals*; Wright's *Birdcraft*; Matthews' *American Wild Flowers*; Keeler's *Our Native Trees*; and Lounsberry's *Southern Wild Flowers and Trees*. The old man had become a new man, but the new man was a man of books...and when the owls began calling, it was in his books that he found comfort. He took up writing, as it was inevitable that he would, setting down by night his experiences of the day."

Kephart became preoccupied with the simple and direct challenge of living efficiently in this new environment. Despite his extensive experiences in the outdoors dating back to childhood, he found that he now "had to make shift in a different way, and fashion many appliances from the materials found on the spot. The forest itself was not only my hunting-ground but my workshop and my garden [so] I gathered, cooked, and ate (with certain qualms, be it confessed, but never with serious mishap) a great variety of wild plants that country folk in general do not know to be edible. I learned better ways of dressing and keeping game and fish, and worked out odd makeshifts in cooking with rude utensils, or with none at all. I tested the fuel values and other qualities of many kinds of wood and bark, made leather and rawhide from game that fell to my rifle, and became more or less adept in other backwood handicrafts, seeking not novelties but practical results."

These "practical results" he published in the popular outdoor magazines of the day. By 1906, he had compiled enough material to put together the first edition of *Camping and Woodcraft*, a storehouse of practical advice, lore, anecdotes and adventures that became the standard work in its field. Supremely applicable, as is no other book in regard to basic techniques and philosophy, it is still in print today via a 1988 University of Tennessee facsimile edition with an introduction by Jim Casada.

In his journals Kephart began to record the exact phrases his neighbors along Hazel Creek used to express their hopes and aspirations as well as their trials and tribulations. This data became the foundation upon which *Our Southern Highlanders* was constructed.

Since 1972, I've been to the cabin site many times. On each occasion, I sit and listen to the wind in the tulip poplars and the tinkling of the creek. Even today, the setting is not so very different from that day in November 1904 when Kephart moved into his cabin and started to explore "that mysterious beckoning hinterland which rose right back of my chimney and spread upward, outward, almost to the three cardinal points of the compass, mile after mile, hour after hour of lusty climbing—an Eden still unpopulated and unspoiled."

After leaving Hazel Creek in 1907, Kephart apparently considered returning there when he came back to the Smokies in 1910; however, because the Ritter Lumber Company had begun extensive operations up the watershed the previous year, he decided to locate in Bryson City instead. But those three years in the cabin on the Little Fork had stimulated Kephart's imagination and writing. It was the place where he sorted out his life anew and laid the foundation for what became a substantial literary and environmental legacy. When he observed toward the end of his life that "I owe my life to these mountains," he no doubt had those years on the Little Fork of the Sugar Fork of Hazel Creek in mind.

In Bryson City, he moved into the Cooper House, an unpretentious boardinghouse just west of the town square in Bryson City. He also rented the office space described by Behymer just around the corner over Bennett's Drug Store.

Our Southern Highlanders was published in 1913 by the Outing Publishing Company in New York. In eight years that edition sold ten thousand copies. In 1922, the Macmillan Company, also of New York, brought out a second edition, which was expanded by three chapters: "The Snake-Stick Man," "A Raid into the Sugarlands" and "The Killing of Hol Rose." This edition added the subtitle *A Narrative of Adventure in the Southern Appalachians and a Study of Life among the Mountaineers*. Macmillan sold thousands upon thousands of copies until it was remaindered in 1967. In 1976, the University of Tennessee Press reissued the Macmillan text in a photo-offset edition, with my biographical introduction, that is still in print. Through the years, that reissue has been one of the University of Tennessee Press's most salable items.

Four things enabled Kephart to craft his book efficiently. First, he was an excellent writer. His prose remains lively and crisp to modern-day sensibilities. And he knew how to mix diverse materials so as to bind them together effectively, a task easier said than done.

Second, he had immersed himself in these materials. Unlike many who wrote (and still write) about the southern mountains and its people, he had experienced and taken part in that life for a number of years.

Third, Kephart had at his disposal that mass of information collected in the journals. To elicit human interest, he employed anecdotes, incidents (both humorous and serious) and comments (often in dialect) that had been carefully recorded. In an outline of the book made before it was finished, he had admonished himself: "To each section apply touchstone of characters known." The journals allowed him to do so; indeed, along with his firsthand observations, it was these materials—especially the dialectical words and expressions recorded firsthand— that enabled Kephart to make his book come to life, as it were, in the reader's hands. He wanted, he later said, to "clothe the bones in flesh and blood." Reading the book is, at times, like hearing the mountain people of that time speak of their hopes and aspirations as well as their fears and misgivings.

And fourth, he knew the literary traditions in which such a book properly belonged. On one hand, it is a continuation of the descriptive, down-home, nitty-gritty and often humorous sort of writing that had been initiated by A.B. Longstreet in *Georgia Scenes* in 1835. On the other, Kephart knew and had himself written about and collected the literature of America's western frontier. Books by George Ruxton and others drew on firsthand experiences to describe an emerging way of life in a lively manner. As a librarian in Saint Louis during the 1890s and the first years of the twentieth century, he became intimately familiar with the numerous journals and diaries that, when subsequently published in book form, became an integral part of western regional literature. For *Our Southern Highlanders*, he created his own journals and a diary (now lost) to draw upon.

The book is a hodgepodge of a book: social study, regional depiction, autobiography and adventure story all rolled into one. In some ways, the autobiographical portions that depict his personal adventures (hunting bears, tracking moonshiners, etc.) are its strongest suit.

In Bryson City, Kephart had access to a far different style of mountain life than he had pursued along Hazel Creek: the leisurely ebb and flow of village life, which quickened only at election time or certain holidays or during court week, itself a sort of holiday. As his fame grew after the publication of *Camping and Woodcraft* and *Our Southern Highlanders*, Kephart found refuge from summer visitors seeking him out by camping at the old Bryson Place, now a designated camping area in the national park, situated about ten miles north of Bryson City alongside Deep Creek. He would sometimes go there for an entire summer, hauling in by wagon or on horseback the supplies and equipment he required, which included a small folding desk and writing materials. While there, he also tested firearms and camping equipment—materials on which he was a recognized national authority—for various companies. Present-day visitors to Bryson Place will find a millstone with a plaque commemorating his use of the site.

It would be wrong, however, to suppose that Kephart was an aloof loner. He had many friends, including George Masa, the great Japanese photographer. And he took part in the civic affairs of Swain County and Bryson City, being a member of the county's chamber of commerce and an elected chairman of the town's board of aldermen. His friend, the pharmacist Kelly Bennett, told me that Kephart instigated the construction of the first sidewalks and streetlights in Bryson City.

On April 2, 1931, at the age of sixty-eight, Kephart was killed in an automobile accident east of Bryson City. A friend, Georgia writer Fiswoode Tarleton, who was staying with Kephart for a few weeks, was also killed. Tarleton was the author of a book about mountain life titled *Bloody Ground* (1929), a cycle of twelve stories set in a fictional town.

It is widely known that Kephart and Tarleton had hired a taxicab driver to take them to a bootlegger near Cherokee. They were on their way back to Bryson City when the driver lost control of the car in a curve. It has been alleged that the driver was also imbibing. Kephart was buried three days after the accident.

In 1994, Swain County native Wilma Ashe, now deceased, prepared for me a typed description of the accident scene that I published, in part, for the first time, in a "Back Then" column written in 2004 as part of the Together We Read activities. Here is the full text of her description:

My cousin, Eugene, was giving me a ride to my home in Whittier after senior play practice at Swain High School. It was about 11 p.m. In front of Oscar Cline's residence in Ela [at the mouth of Coopers Creek on the highway between Bryson City and Cherokee] the flicker of a small flashlight was being swung beside the road by Oscar's wife, Sally. We were the first car to stop and discovered it was a car overturned. With the light from our car and Sally's flashlight, we could see bodies pinned in the car. They were silent! The first man pulled out was Mr. Brown, the taxi driver. He could not speak but was breathing and alive. We stretched his body out on the side of the road and quickly turned to the wrecked car. There was a body pinned between the car and the bank. It took all three of us pulling and lifting to move the car off his body and pull it out to the roadside. We realized there was no life. He had no visible injuries. I remarked "I've seen this man before, I think I know him." I opened his jacket front and in his breast pocket was a letter addressed to "Horace Kephart." I said "Oh, that's who it is!" We looked up as a car that had stopped was pulling off into the road. It was too far for us to reach Mr. Brown, who was swinging on the spare tire on the rear of the car. They went out of sight. I never heard of him anymore or the details. We returned to the next victim [Tarleton] in the car. He was a huge man [and] had no doubt died instantly.

The funeral was held for these two victims at the Swain High School auditorium on the following Sunday afternoon. All the churches took part in the service. That was 63 years ago. I had just had my 17th birthday, but I remember I was asked to serve as an usher. The auditorium was filled to capacity. No doubt this was the biggest and greatest funeral ever held in Bryson City.

The Great Smoky Mountains National Park wasn't officially founded until three years after Kephart's death, but he died knowing that the park was going to be a reality. Indeed, shortly before his death, he had represented Swain County in Washington, D.C., when state officials from North Carolina and Tennessee transferred the titles of the lands purchased by them to be used for the park over to the U.S. government.

Since the mid-1920s Kephart had devoted most of his time and energy to the movement that eventually established a national park in the Great Smokies—the first large one east of the Mississippi, presently composed of more than 520,000 acres. As indicated earlier, Kephart's inner motivations for this level of commitment can be readily surmised. He had arrived in the Smokies region seeking a place where he might engage in a healing process that involved a rural lifestyle. And that place of refuge was exactly what he found, especially at his remote cabin site deep in the heart of the Smokies. Those three years became for him a spiritual touchstone of sorts, providing the vivid experiences that fueled his desire to see the region preserved as a national park. His public explanation was to the point: "I owe my life to these mountains and I want them preserved that others might benefit by them as I have." It was that simple.

Kephart joined forces with the Japanese photographer George Masa, whose studio was located in Asheville, but who spent as much time in Bryson City and the Smokies with "Kep" as he could. They were close friends and a formidable duo when it came to promoting the national park concept: Kephart wrote magazine and newspaper articles articulating the concept that were illustrated by Masa's scenic images.

A seminal publication of this sort was a large-format pamphlet titled *A National Park in the Great Smoky Mountains*, published by the Swain County Chamber of Commerce, that appeared in 1925. By this point in time, Kephart was a member of that organization, as was his pharmacist friend Kelly Bennett, an ardent park supporter who served several terms in the state legislature.

The pamphlet consisted of Kephart's text, which explored topics like "Why National Parks Are Needed," "A New Wonderland," "The Forest of the Great Smokies," "Roads to the New Park" and "Ideal Camping Country," and five of Masa's images. These included a cover shot titled *Sunrise in the Smokies* (probably taken from Andrews Bald) that captured mist rising in the valleys far below. There were also two full-page maps. One provided the big picture, depicting "Main Routes to Neighboring States." The other provided a close-up perspective of "The Smoky Mountains National Park and Its Environs" in relation to Western North Carolina and East Tennessee. This sort of systematic approach became a hallmark of the park movement.

Rightly, no single individual has been recognized as the father of the Great Smoky Mountains National Park. Many on the local, regional, state and national levels contributed significantly. The fairest and most readable overview of this aspect of the park's history is put forth in Daniel S. Pierce's *Great Smokies: From Natural Habitat*

to National Park (2000). Pierce was on target when he placed Kephart's contributions among the "heroic efforts of regional boosters like David Chapman, Ann Davis, W.P. Davis, Horace Kephart, Mark Squires, and Charles Webb." Kephart's name, however, has stood out through the years, in part because his contributions were substantive but also because—unlike all others—he wrote *Our Southern Highlanders* and became a colorful, somewhat controversial and widely recognized figure. On the national level his was one of the names most closely associated with the southern mountains in general and the Great Smoky Mountains National Park movement in particular. It's not improbable that, despite the occasional carping by would-be revisionists, this will continue to be the case.

From the ridge about half a mile above Kephart's gravesite, which overlooks downtown Bryson City, one has a panoramic view to the north out over the town up the Deep Creek watershed to the high crest that divides North Carolina and Tennessee. Newfound Gap, where the transmountain highway crosses the state line between Cherokee and Gatlinburg, is clearly delineated even at this distance. One could stop there at the parking area, read a plaque stating that this is the spot where President F.D. Roosevelt dedicated the national park in 1940 and then walk north a few miles along the Appalachian Trail to Mount Kephart.

Two months before his death, Kephart was honored by a decision of the U.S. Geographic Board designating that this peak at 6,217 feet be named in his honor. Some years later a rise on the southwestern side of Mount Kephart was named Masa Knob. At that spot the contributions of the two friends—mountain spirits, if you will—are properly commemorated.

The grand finale for the 2004 Together We Read program took place at Pack Memorial Library in Asheville in November of that year. In addition to a brief talk about Kephart by this writer, Western North Carolina Heritage Awards were presented to nineteen institutions and heritage-related groups.

One of these was presented to the Special Collections section of Western Carolina University's Hunter Library for the creation of a website titled Horace Kephart: Revealing an Enigma. The program brochure for this award, accepted by WCU archivist George Frizzell, reads: "Using a variety of media, the library has created an archive around the life and times of Horace Kephart. The website presents photos, artifacts, documents, writing, maps, and links to other sources of information." This website is a truly informative and lively presentation that will, in time, make available online a significant portion of Kephart's journals. (The website's address is provided in my list of sources along with the "Frizzell" entry.)

I can't help but wonder what Horace Kephart would make of this latest twist in his curious story. Sitting alone—and, no doubt, somewhat forlorn—in that lamp-lit, remote cabin on the Little Fork of the Sugar Fork of Hazel Creek a hundred years ago, there's absolutely no way he could have envisioned a multimedia website created by a university library in his honor.

Stark Love: Karl Brown's 1927 Mountain Movie

Back in 1927, a controversial and historically significant Paramount Pictures silent film titled *Stark Love* was shot in Graham County by writer-director Karl Brown, a former student of silent film legend D. W. Griffith.

Insofar as I am aware, only three copies of the film survive: one at the Museum of Modern Art in New York City and the other at the Library of Congress in Washington, D.C. These archival copies were made in 1968 when British film historian Kevin Brownlow discovered a single surviving copy in the Czech Film Archive in Prague, Czechoslovakia.

The film is described in "Hollywood in the Hills: The Making of 'Stark Love,'" an essay by Jerry Williamson, an authority on Appalachian films and longtime editor of the *Appalachian Journal*, in which the essay appeared. Of the more than seven hundred Hollywood mountain movies made by the early 1990s—from *The Moonshiners* in 1904 on down to the more recent *Sergeant York* and *Thunder Road*—Williamson considered *Stark Love* to be one of the most important ever made about Appalachia, all the more so since it was shot here in the southern mountains rather than in Hollywood.

Along with his essay, Williamson reprinted a forty-six-page section of Karl Brown's manuscript titled "The Making of *Stark Love*: From *The Paramount Adventure*," material that provides the author's recollections of Graham County and its people in the 1920s. Therein, Brown also records "his efforts to find amateur actors in an area where movies were considered sinful by most" and his

relationship with Horace Kephart, author of *Our Southern Highlanders*. Moreover, a short "Introduction" by Kevin Brownlow on how he found the reclusive Brown (who died in 1990) and induced him to write about these matters is included.

While filming *The Covered Wagon* in the Utah desert, Brown happened to read in an old *Atlantic Monthly* magazine a chapter by Lucy Furman that later appeared in her 1923 novel titled *The Quare Women: A Story of the Kentucky Mountains*. This, he said, was his initial inspiration for *Stark Love*. So, he went looking for a location for his planned movie.

Brown wanted some "authentic" mountain people to appear in it, having been influenced in this regard by the recent successes of documentary movies like *Nanook of the North*, which had presented real people on film, not actors. He first visited Berea College in Kentucky, then Nashville and Knoxville and finally Asheville, where he found topographic maps showing "the highest valleys of the Smokies, near such fascinating places with names such as Nantahala, Shuckstack, Siler's Bald and any number of similarly romantic place-names."

He also chanced upon a copy of *Our Southern Highlanders*, first published in 1913 and enlarged in a subsequent edition in 1922. Brown felt he'd found someone who could provide assistance, so he went to Bryson City to meet the author in the fall of 1925. Although highly colored in places, Brown's description of Kephart is one of fullest firsthand profiles available:

> We stored our gear in baggage rooms [at the Bryson City railway station] while we wandered up the street looking for someone who might give us news of Kephart. Suddenly I saw and recognized him, standing negligently before the town's one hotel...[He] was a small man, something below medium height, but chunky and intrinsically formidable. But the one feature that distinguished him from all other human beings I have ever met was that one of his eyes was a bright blue while the other was a deep brown...We crossed the street and ascended some wonderfully uneven steps [over old Bennett's Drug Store just north of the town square] to land in an equally wonderful uneven office with a floor that was as wavy as a mild sea.
>
> Kephart's desk was of the old rolltop kind, his typewriter, a battered old Underwood 5. The nearby table was piled high with books, papers, magazines and letters, with everything piled on top of everything else. On the floor beside the desk lay a coil of twisted galley-proofs, waiting for some kindly soul to correct them. A few old pipes, thick-crusted and rank, lay on the desk while cloth bags of Havana clippings were handy to fuel these mephitic tobacco burners.
>
> Kephart leaned back in his creaky-springed swivel chair and said, as a sort of cue, "Well?"...I decided then and there that this was no man to fool with. There was something so direct and honest in his bearing that he reminded me of others of his kind...so, even though I knew in advance it would be an uphill job, I decided to be as honest as I could manage, considering that I was somewhat out of practice.

Kephart, who had already heard about Brown's desire to portray mountain people, advised Brown to "be a gentleman and you'll be treated like one" and that

"honesty is not only the best policy: it is the only one." He introduced Brown around and arranged for a mountain guide named Jim Bob Marcy to assist him in Graham County, situated to the west of Bryson City on the state line with Tennessee.

Although highly colored, too, Brown's account of his sojourn in far southwestern North Carolina is both entertaining and informative:

> *Jim Bob drove us first to the baggage room where we picked up our camera equipment, and then he headed us out of town over a road which I would never compliment by calling it merely atrocious. On and on we went, heading straight up or straight down, sometime on tire-tracks that served as roads and once or twice bumping and rocking along stream beds which were the only roads possible in those pinched-in guts of cliffs…There was one store that carried everything from meat to mortuary necessities. Bib overalls, the uniform of the mountaineers, hung in racks close to the barrel of salt pork, the only meat-product on sale. There was a village square, standard equipment of all towns large and small, from Boston Common to this barely perceptible dot on the map called Robbinsville.*

Brown changed guides in Robbinsville, recruiting a local man to take them into the Santeetlah area of Graham County. On Christmas Day in 1925, he was still camping out in an open area he called the "polo field." There he made contact with a gentleman named Shotgun John Smith, who helped him meet others that might take part in the film.

Brown was especially looking for a fiery young girl who could play the lead in his movie. And he found her, but her father was suspicious of the "movie fellow" and wouldn't consent, saying that none of the women in his family would become "movie Jezebels."

Brown learned, however, from Shotgun John that the man's daughter had been promised in marriage to a man whose own son became his chief rival for her affection. Suddenly, he had the rest of his story idea: a beautiful, spirited mountain girl fought over by a mountain man and his own son.

During this visit, Brown took shots that would eventually be in the movie: log cabins, people working in fields, a man making shingles, scenery and so on. And then, in the summer of 1927, he returned with plenty of financial backing from Paramount to set up a "base camp" in an abandoned store building at the end of Robbinsville's main street.

In an outburst of activity that must have amazed town residents, "Lines of communication were established for meats, vegetables, and fresh fruits. Lumber of all sizes appeared, enough for a small town. A huge army-type range was brought up in sections. A cook and flunkies reported for duty. Everything flowed into town, then out along the trail after being divided into mule loads."

Unable to find locals to take the principal parts, he sent an assistant, Colonel Paul Wing, to Knoxville. Wing reported back with one Helen Mundy, an eighteen-year-

old "mischievous little gamin" who became a local legend in Robbinsville. Worried about appearances as well as actual scandal, Brown said that he paid the local sheriff money so that extra deputies could be hired to keep an eye out for Helen Mundy.

When the film was finished, Paramount didn't quite know what to do with it. It was like nothing else ever done. On the one hand, it was so much like a documentary and totally non-urban as to make the company nervous for its reception; on the other, it was so blatantly violent and sexually suggestive—there's a violent attempted rape at the end—as to invite the censor's condemnation.

Brown had a hard time getting it shown, so he finally rented a theater in New York City and staged his own premier. The print that was shown had been heavily edited to tone down the concluding rape and fight scenes.

When *Stark Love* was eventually shown in Robbinsville, the people, understandably, were not amused. But, in retrospect, Brown's memoir about the making of the film provides a document that opens a window on how outsiders viewed and related to this region during the first half of the twentieth century. And, in some ways, things hadn't changed all that much by the second half of the century. After all, when the movie *Deliverance* appeared in the early 1970s, it brought people streaming into movie theaters looking for the romantic, the picturesque and the grotesque.

Kephart Prong:
Past and Present

Ilike locating and visiting those sites here in Western North Carolina where one can experience what I think of as being a series of "overlays," that is, places where significant aspects of both the natural world and the human history of a given area commingle. At such places, one can encounter the confluence of all or several of the major strands in the region's natural and cultural fabric: wild areas, plants and animals; early Cherokee and pioneer settlement influences and the impacts of the modern era, initiated here most significantly with the coming of the railroad in the late nineteenth century. At such places the prepared observer can experience what the French have called *frisson*: a moment of excitement and maybe even insight that arises when these various forces coalesce.

One such place exists, for me, along the lower portions of the Kephart Prong Trail in the Great Smoky Mountains National Park. The trailhead is situated at a bridge on the right side of the Newfound Gap Road (U.S. 441), about seven miles west of the Oconaluftee Visitors Center.

Kephart Prong is a small stream so named because it flows from its headwaters on Mount Kephart into the Oconaluftee River near the trailhead. This trail extends two miles from 2,750 feet to its junction at 3,600 feet with the Sweet Heifer and Grassy Branch Trails, where a shelter is situated. One guidebook accurately described it as "a riverine stroll." Unless you're disabled in some manner, it's quite doable. If for whatever reason you're not up to the full four-mile round-trip, the first mile or so will provide plenty to see and think about.

Situated in the heart of the prehistoric Cherokee homeland, Kephart Prong is a beautiful creek, not so expansive as Hazel or Deep creeks elsewhere in the park, but with a vivacity all it own as it plunges and tumbles over huge boulders and forms rivulets in the main and side channels. Unlike most of the creeks in the park, there are numerous areas along its lower portions where the stream has at high-water levels formed bends and oxbows that become mucky sloughs during normal stream flow.

There are numerous trees and shrubs of interest, including oil-nut, witch hazel, strawberry-bush, three maple species (striped, red and sugar) and three species of deciduous magnolia (cucumber, umbrella and Fraser's). A good-sized tulip poplar tree can be located just to the right of the trailhead.

But here, where the natural world is slowly reclaiming its primeval grandeur, there are other sorts of nonnative plants that indicate human activity on a large scale. About a quarter mile above the trailhead, you'll commence spotting large boxwoods and a stand of arborvitae. Company 441 of the Civilian Conservation Corps was stationed here from 1933 to 1942. An old pump, a low stone wall, a huge masonry "message board," a hearth, pieces of pipe and a twenty-foot-high chimney are some of the material evidence left over from those long-ago days.

From the late 1930s into the early 1940s, twenty-three Civilian Conservation Corps camps were established in the park, which was officially founded in 1934. At the time of peak enrollment (1934–35), 4,350 men worked out of military-style camps. They were paid thirty dollars a month and sent twenty-five dollars of it home to their families. The CCC boys were noted for their fine work, much of which is still in evidence.

All in all, Company 441 (composed of about two hundred young men at any given time) improved twenty miles of primary and secondary roadways; constructed sixty-five miles of trails and twenty-two fish-raising ponds; established a water system for Newfound Gap as well as a parking area for six hundred cars and planted a hundred thousand or so trees in the immediate vicinity, which had been denuded by logging activities.

At about half a mile above its trailhead, the trail passes through a thicket of rosebay rhododendron and crosses a footbridge over Kephart Prong. Alongside the trail, several hundred yards up the slope from this bridge, you'll spot the remains of what was once an extensive fish hatchery (rainbow trout and smallmouth bass), which was established in 1936 by the federal Work Projects Administration. An old photo I have seen of the fish hatchery shows several buildings, a house and twenty-five or so rock-rimmed fish ponds, each about ten feet in diameter. Established to supply game fish in the park as a part of the growing tourist economy in Western North Carolina, the facility hatched a half million trout eggs in December 1936 alone. A large concrete platform, a cistern and two concrete tanks are all that remains today of that operation.

A mile above the trailhead, you'll cross another footbridge. Pause and admire the Civilian Conservation Corps stonework, which provides the support for an immense tulip poplar log with flattened topside that traverses the creek. In places, the trail presently follows a railway bed constructed by the Champion Fiber Company in the early 1920s.

Once a hushed woodland setting, the area was at that time alive with loggers, Shay locomotives, switchbacks and steam-powered overhead skidders. Their prime objective was harvesting the extensive stands of red spruce in the upper reaches of the Oconaluftee watershed. That logging company eventually clear-cut more than two thousand acres of spruce in this immediate region.

The Kephart Prong Trail provides food for thought, a *frisson* between the past and present states of a mountain watershed. Much has taken place here—some of it very good, some of it dubious at best—but all of it part and parcel of the ongoing history and legacy of this immediate region. I'm of the opinion that it's fruitful to visit such places from time to time and mull things over.

One final thought. It helps to do some preparation—talking with people, reading, studying maps, whatever—if you're going to be prepared to anticipate and then fully appreciate the various potentialities that might be overlaid at a given site.

(Sources for this account are Dick Murlless and Constance Stallings, *A Sierra Club Totebook: Hiker's Guide to the Smokies*; Don DeFoe, et al., *Hiking Trails of the Smokies*; Daniel S. Pierce, *The Great Smokies: From Natural Habitat to National Park* and Michal Strutin, *History Hikes of the Smokies*.)

Sources

Adair, James. 1775. *The History of the American Indians*. London: Printed for Edward and Charles Dilly.

Anderson, William L., ed. 1991. *Cherokee Removal: Before and After*. Athens: University of Georgia Press.

Arthur, John Preston. 1914. *Western North Carolina: A History (from 1730 to 1913)*. Asheville, NC: Edward Buncombe Chapter of the Daughters of the American Revolution.

————. 1915. *A History of Watauga County: With Sketches of Prominent Families*. Richmond, VA: Everett Waddey.

Ashe, Wilma McHan. 1994. "The Night Horace Kephart Died." Two pages typed, written for George Ellison on April 6; original on deposit in Special Collections, Hunter Library, Western Carolina University, Cullowhee, NC.

Behymer, F. A. 1926. "Horace Kephart, Driven from Library by Broken Health, Reborn in Woods." *St. Louis Post-Dispatch*, as reprinted in the *Asheville Citizen-Times* December 12.

Bessent, Helgar, photographer. 2000. "Thomas Wolfe's Angels: A Photographic Odyssey." *Duke University Libraries* 14 (1). http://magazine.lib.dukc.edu/issue4/libmag1000.swf.

Broome, Harvey. 1975. *Out Under the Sky of the Great Smokies: A Personal Journal*. Knoxville: The Greenbrier Press.

Brown, Margaret Lynn. 2000. *The Wild East: A Biography of the Great Smoky Mountains*. Gainesville: University of Florida Press.

Byrd, William. 1929. "History of the Dividing Line Run in the Year 1728." In *William Byrd's Histories of the Dividing Line Betwixt Virginia and North Carolina*. Raleigh: North Carolina Historical Commission.

Cairns, John C. 1891. *List of the Birds of Buncombe County, North Carolina*. Weaverville, NC: John C. Cairns.

Caras, Roger A. 1967. *North American Mammals: Fur-Bearing Animals of the United States and Canada*. New York: Galahad.

Coggins, Allen R. 1999. *Place Names of the Smokies*. Gatlinburg, TN: Great Smoky Mountains Natural History Association.

Cooper, Horton. 1967. *The History of Avery County, North Carolina*. Asheville, NC: Biltmore.

Crellin, John K., ed. 1988. *Plain Southern Eating*. Durham, NC: Duke University Press.

———. 1997. "A.L. Tommie Bass: 1908–1996." *HerbalGram: The Journal of the American Botanical Council* (39). http://www.herbalgram.org/wholefoodsmarket/herbalgram/articleview.asp?a=503.

Crellin, John K., and Jane Philpott. 1989. *Herbal Medicine, Past and Present*. 2 vols. Durham, NC: Duke University Press.

Davis, Hattie Caldwell. 1997. *Cataloochee Valley: Vanished Settlements of the Great Smoky Mountains*. Alexander, NC: WorldComm.

Davis, Rebecca Harding.1880. "By-Paths in the Mountains. Part III." *Harper's New Monthly Magazine* 61 (September).

DeFoe, Don, et al. 1994. *Hiking Trails of the Smokies*. Gatlinburg, TN: Great Smoky Mountains Natural History Association.

Dykeman, Wilma. 1955. *The French Broad*. New York: Rinehart.

Ellison, George. 1988. "Mark Cathey." In *The Heritage of Swain County, North Carolina*, ed. Hazel C. Jenkins. Winston-Salem, NC: History Division of Hunter Publishing.

———. 1990. "Here's a New Candidate for Wolfe Angel." *Smoky Mountains Neighbors* (weekly supplement of *Asheville Citizen-Times*) July 25–26.

Faulkner, William. 1950. *Requiem for a Nun*. New York: Random House.

FitzSimons, Frank L. 1976, 1977, and 1979. *From the Banks of the Oklawaha: Facts and Legends of the North Carolina Mountains*. 3 vols. Hendersonville, NC: Golden Glow.

Fleming, Karl. 1959. "Indian Twice Sold Land That Is Now Bryson City." *Asheville Citizen-Times*. Reprinted in Lillian Thomasson, *Swain County: Early History and Educational Development* (Bryson City, NC: Lillian Thomasson, 1965).

Fogelson, Raymond D., and Amelia B. Walker. 1980. "Self and Other in Cherokee Booger Masks." *Journal of Cherokee Studies* 5 (Fall).

Fradkin, Arlene. 1990. *Cherokee Folk Zoology: The Animal World of a Native American People, 1700–1838*. New York: Garland.

Frizzell, George, archivist. n.d. Horace Kephart: Revealing an Enigma. Special Collections, Hunter Library, Western Carolina University. http://www.wcu.edu/library.

Hall, Joseph S. 1960. *Smoky Mountain Folks and Their Lore*. Asheville, NC: published in cooperation with Great Smoky Mountains Natural History Association.

Hodge, H.A., ed. *Swain County Herald*. Materials related to Geronimo appeared from July 1889 until at least December 1890. Extant issues for this period (January 3,1889–December 18, 1890) available on microfilm at Hunter Library, Western Carolina University, Cullowhee, NC.

Hornaday, William T. 1889. *The Extermination of the American Bison*. Washington, DC: Smithsonian Institution.

Jackson, Dot. n.d. "In Search of the Angelic Muse." *The Independent Weekly*. Photocopy of text without citation mailed in 1990s from author to George Ellison.

Jones, Perry. 1959. *The European Wild Boar in North Carolina*. Raleigh: North Carolina Wildlife Resources Commission.

Kemp, Steve, ed. 1998. *Waterfalls—Great Smoky Mountains National Park*. Gatlinburg, TN: produced by Great Smoky Mountains Natural History Association in cooperation with the National Park Service.

Kephart, Horace. 1925. *A National Park in the Great Smoky Mountains*. Photographs by George Masa. Bryson City, NC: Swain County Chamber of Commerce.

————. 1976. *Our Southern Highlanders: A Narrative of Adventure in the Southern Appalachians and a Study of Life among the Mountaineers*. Introduction by George Ellison. Knoxville: University of Tennessee Press; facsimile of 1922 edition, New York: Macmillan; first edition, 1913, New York: Outing.

————. 1988. *Camping and Woodcraft: A Handbook for Vacation Campers and for Those Travelers in the Wilderness*. Introduction by Jim Casada. Knoxville: University of Tennessee Press; facsimile of 1917 edition, New York: Macmillan; first edition, 1906, in 2 vols., New York: Outing.

Kilpatrick, Alan. 1997. *The Night Has a Naked Soul: Witchcraft and Sorcery among the Western Cherokee*. Syracuse, NY: Syracuse University Press.

King, Duane. 1976. "A Powder Horn Commemorating the Grant Expedition against the Cherokees." *Journal of Cherokee Studies* 1 (Summer).

————, ed. 1979. Tsali Issue. *Journal of Cherokee Studies* 4 (Fall).

Lathrop, Virginia T. 1949. "Hendersonville Monument Identified as Thomas Wolfe's 'Angel.'" *Asheville Citizen-Times* November 20.

Lewis, Ralph H. 1993. *Museum Curatorship in the National Park Service, 1904–1982*. Washington, DC: Department of the Interior, National Park Service, Curatorial Services Division. www.cr.nps.gov/history/online_books/curatorship.

Lord, William G. 1981. *Blue Ridge Parkway Guide: Grandfather Mountain to Great Smoky Mountains National Park*. Birmingham, AL: Menasha Ridge Press.

Mooney, James. 1932. *The Swimmer Manuscript: Cherokee Sacred Formulas and Medical Prescriptions*. Revised, completed, and edited by Frans M. Olbrechts. Washington, DC: Government Printing Office. (For provenance and questions involving authorship of this text, see introduction to *James Mooney's History, Myths, and Sacred Formulas of the Cherokees [Mooney 1992]*.)

————. 1992. *James Mooney's History, Myths, and Sacred Formulas of the Cherokees*. Introduction by George Ellison. Asheville, NC: Historical Images; facsimile of 1900 edition of *Myths of the Cherokee*, Washington, DC: Government Printing Office, and 1891 edition of *The Sacred Formulas of the Cherokees*, Washington, DC: Government Printing Office.

Murlless, Dick, and Constance Stallings. 1973. *A Sierra Club Totebook: Hiker's Guide to the Smokies*. San Francisco: Sierra Club.

North, Hayden. 1947. *The Marble Man's Wife: Thomas Wolfe's Mother*. New York: Scribner's.

Owle, Lloyd. 1981. "Indian Turtle Shells." In *The Cherokee Perspective: Written by Eastern Cherokees*, eds. Laurence French and Jim Hornbuckle. Boone, NC: Appalachian Consortium Press.

Patton, Darryl. 1988. *Tommie Bass...Herb Doctor of Shinbone Ridge*. Birmingham, AL: Back to Nature.

Peattie, Roderick, ed. 1943. *The Great Smokies and the Blue Ridge: The Story of the Southern Appalachians*. New York: Vanguard.

Pierce, Daniel S. 2000. *The Great Smokies: From Natural Habitat to National Park*. Knoxville: University of Tennessee Press.

Powell, William S. 1968. *The North Carolina Gazetteer: A Dictionary of Tar Heel Places*. Chapel Hill: University of North Carolina Press.

Powers, Elizabeth D., with Mark Hannah. 1982. *Cataloochee, Lost Settlement of the Smokies*. Charleston, SC: Powers-Hannah.

Sakwoski, Carolyn. 1990. *Touring the Western North Carolina Backroads*. Winston-Salem, NC: John F. Blair.

Simpson, Marcus B. Jr. 1978. "The Letters of John S. Cairns to William Brewster, 1887–1895." *North Carolina Historical Review* 55 (July).

———. 1979. "John S. Cairns." *Dictionary of North Carolina Biography* vol. 1, ed. William S. Powell. Chapel Hill: University of North Carolina Press.

———. 1980. "William Brewster's Exploration of the Southern Appalachian Mountains: The Journal of 1885." *North Carolina Historical Review* 57 (January).

Smith, Bruce D. 1995. *The Emergence of Agriculture*. New York: Scientific American Library.

Spangenberg, Augustus Gottlieb. 1922. "The Spangenberg Diary." In *Records of the Moravians in North Carolina*, vol. 1, ed. Adelaide L. Fries. Raleigh: North Carolina Historical Commission.

Speck, Frank G., and Leonard Broom in collaboration with Will West Long. 1951. *Cherokee Dance and Drama*. Berkley: University of California Press.

Spongberg, Stephen A. 1990. *A Reunion of Trees: The Discovery of Exotic Plants and Their Introduction into North American and European Landscapes*. Cambridge: Harvard University Press.

Strutin, Michal. 2003. *History Hikes of the Smokies*. Gatlinburg, TN: Great Smoky Mountains Natural History Association.

Stupka, Arthur. 1963. *Notes on the Birds of Great Smoky Mountains National Park*. Knoxville: University of Tennessee Press.

Tinsley, Jim Bob. 1988. *The Land of Waterfalls: Transylvania County, North Carolina*. Kingsport, TN: Kingsport Press.

Trout, Ed. 1995. *Historic Buildings of the Smokies*. Gatlinburg, TN: Great Smoky Mountains Natural History Association.

Webster, William David, et al. 1985. *Mammals of the Carolinas, Virginia and Maryland*. Chapel Hill: University of North Carolina Press.

Williams, Walter L. 1977. "The Merger of Apaches with Eastern Cherokees: Qualla in 1893." *Journal of Cherokee Studies* 2 (Spring).

Williamson, Jerry. 1991. "'Hollywood in the Hills: The Making of *Stark Love*,' including an 'Introduction' by Kevin Brownlow and '[The Making of *Stark Love*] from *The Paramount Adventure*' by Karl Brown." *Appalachian Journal* 18 (Winter).

Worcester, Donald E. 1979. *The Apaches: Eagles of the Southwest*. Norman: University of Oklahoma Press.

Zeigler, Wilbur G., and Ben S. Grosscup. 1883. *The Heart of the Alleghanies or Western North Carolina: Comprising Its Topography, History, Resources, People, Narratives, Incidents, and Pictures of Travel, Adventures in Hunting and Fishing, and Legends of Its Wilderness*. Raleigh, NC: Alfred Williams.

About the Author and Illustrator

George and Elizabeth Ellison moved with their children to Western North Carolina in 1973. George's office is situated at Elizabeth Ellison Watercolors, a gallery-studio his wife—the noted papermaker and watercolorist who executed the cover illustration for *Mountain Passages*—operates on the town square in Bryson City. Since 1976, they have made their home in a forty-six-acre cove surrounded on three sides by the Great Smoky Mountains National Park.

George writes and lectures about the natural and human history of Western North Carolina. His "Nature Journal" column, illustrated by Elizabeth, appears every other week in the *Asheville Citizen-Times*, and his "Botanical Excursions" column is published quarterly in *Chinquapin: The Newsletter of the Southern Appalachian Botanical Society*. For many years, George has served as a field trip leader for bird, wildflower and fern identification workshops offered by the Native Plant Conference sponsored by Western Carolina University, the North Carolina Arboretum, Southwestern Community College and the Smoky Mountain Field School, as administered by the University of Tennessee for the Great Smoky Mountains National Park.

George wrote the biographical introductions for the reissues of two Southern Appalachian classics: Horace Kephart's *Our Southern Highlanders* (University of Tennessee Press, 1976) and James Mooney's *History, Myths and Sacred Formulas of the Cherokees* (Historical Images, 1992). Since 1990, he has conducted a number of Elderhostel programs at various institutions about either Cherokee or white mountaineer history and culture.

For the past four years, George has contributed a weekly column titled "Back Then" to *Smoky Mountain News*, a regional newsmagazine published in Waynesville and distributed in the North Carolina counties west of Asheville. The selections presented in this volume originated, in their present form, in that column.

For additional information about George and Elizabeth and how to contact them, visit either www.georgeellison.com or www.elizabethellisonwatercolors.com.

Available Now

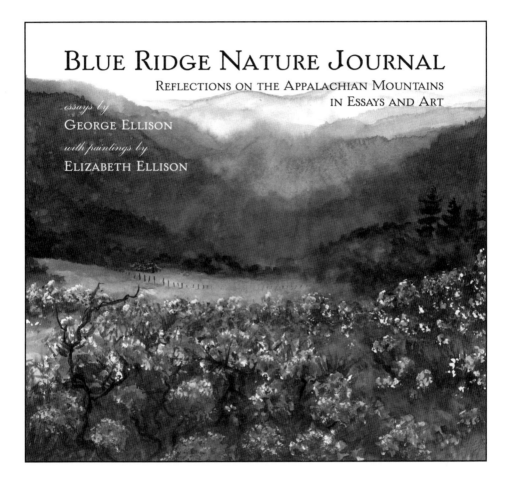

Blue Ridge Nature Journal
Reflections on the Appalachian Mountains in Essays and Art

George and Elizabeth Ellison

Few regions of the continental U.S. can match the magnificent natural wonder of the Blue Ridge. Field naturalist and author George Ellison calls upon a lifetime of experience to illuminate the extraordinary natural history of the Blue Ridge through a series of masterfully written essays. Featuring a collection of full-color artwork by renowned watercolorist Elizabeth Ellison.